Pen & Ink With Watercolor

George Olson

NORTH LIGHT BOOKS
CINCINNATI, OHIO
www.artistsnetwork.com

Other fine North Light Books are available from your local bookstore, art supply store or direct from the publisher.

10 09 08 07 06 5 4 3 2 1

DISTRIBUTED IN CANADA BY FRASER DIRECT
100 Armstrong Avenue
Georgetown, ON, Canada L7G 5S4
Tel: (905) 877-4411

DISTRIBUTED IN THE U.K. AND EUROPE BY DAVID & CHARLES
Brunel House, Newton Abbot, Devon, TQ12 4PU, England
Tel: (+44) 1626 323200, Fax: (+44) 1626 323319
Email: mail@davidandcharles.co.uk

DISTRIBUTED IN AUSTRALIA BY CAPRICORN LINK
P.O. Box 704, S. Windsor NSW, 2756 Australia
Tel: (02) 4577-3555

Library of Congress Cataloging in Publication Data
Olson, George, 1936-
Pen & ink with watercolor / George Olson.
 p. cm.
Includes index.
ISBN-13: 978-1-58180-754-7 (alk. paper)
ISBN-10: 1-58180-754-6 (alk. paper)
1. Pen drawing--Technique. 2. Ink painting--Technique. I. Title: Pen and ink with watercolor. II. Title.
NC905.O47 2006
741.2'6--dc22 2006002774

Edited by Mona Michael
Designed by Wendy Dunning
Production art by Sean Braemer
Production coordinated by Matt Wagner

ABOUT THE AUTHOR

Artist and architect George Olson has been a master of his craft for the last four decades and is considered one of a few remaining old-world style pen-and-ink artists using the crow quill pen and India ink. He was born and raised in Montana with the Bob Marshall Wilderness as his playground and inspiration.

Although his career began in architecture, he continually pursued his love of art. His work in the architectural department of the Church of Jesus Christ of Latter-day Saints enabled him and his wife, Ruth, to travel throughout Europe and other parts of the world, learning from the masters and honing his own style.

After living and working in Great Britain and other areas of the United States, George and Ruth now live in Mount Pleasant, Utah, where they enjoy living in a mountain cabin surrounded by Mother Nature's best.

George is now devoting his time to fine art. He has added watercolor to his beautiful pen-and-ink works and loves to experiment in other mediums. His collective works of the past and new works of today are available in galleries and online at www.olsongalleries.com.

Metric Conversion Chart

To convert	to	multiply by
Inches	Centimeters	2.54
Centimeters	Inches	0.4
Feet	Centimeters	30.5
Centimeters	Feet	0.03
Yards	Meters	0.9
Meters	Yards	1.1

ART ON PAGE 2

LEGACY BRIDGE
INDIA INK ON PAPER
14" × 18" (36CM × 46CM)

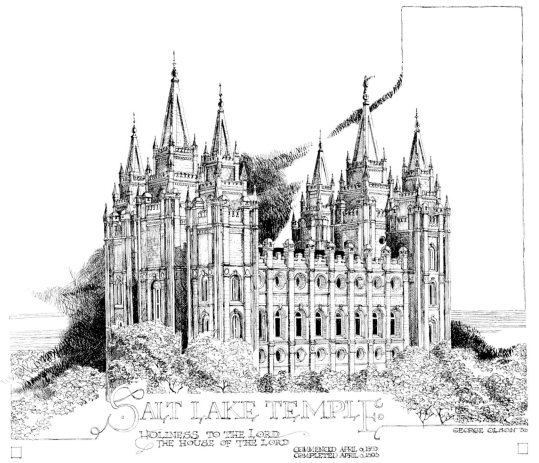

SALT LAKE TEMPLE

INDIA INK ON ILLUSTRATION BOARD

20" × 30" (51CM × 76CM)

ACKNOWLEDGMENTS

It is impossible to accomplish anything without being influenced by other people. In my case there have been many: my art teacher, Mrs. Tonkin; architectural instructor, John DeHaas; my mother who encouraged me in life and art at an early age; my six dear daughters, Liesl, Gorgi, Darci, Heather, Danni and Brittoni; and my wife, Ruth, also a talented artist, who has been my moral support for forty-three years. To my editors, Pam Wissman and Mona Michael, a special thanks for being so encouraging and patient with me.

DEDICATION

To all of you who are influenced by this book to learn the joy of creating art with pen and ink, I dedicate this book. And to the One who gave us all our talents to develop and enjoy.

Table of Contents

1
GETTING STARTED

10

Crow Quill Pens ∼ Inks ∼ Drawing Surfaces

Additional Supplies ∼ Where to Draw ∼ Sketching Outside

Exercise: Warm-Ups ∼ Holding the Crow Quill ∼ Loading the Crow Quill

Exercise: Using the Crow Quill Pen ∼ Exercise: Line Practice

Exercise: Curve Practice ∼ What to Draw ∼ Proportion and Perspective

Equipment for Reference Photos ∼ Using Reference Photos

Exercise: Working From Reference Photos

2
BASIC PEN & INK
36

3
ADDING COLOR
68

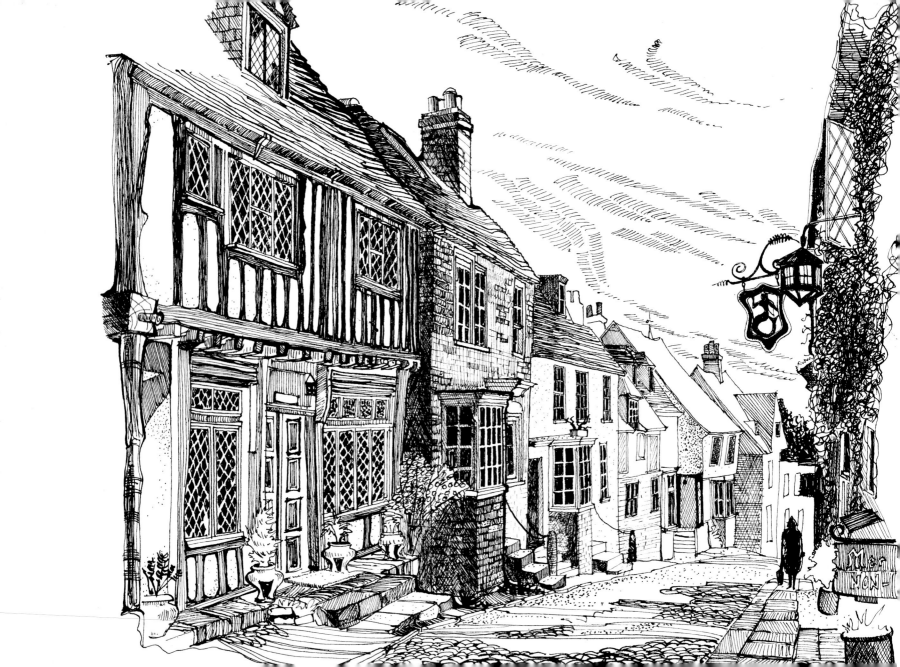

INTRODUCTION

As young students in architecture in Montana, we were required to produce sketches of historical subjects, mostly of buildings and monuments, representing the major architectural periods of time in history. I chose to sketch these in pen and ink because I felt the character of ink lent itself to the feeling of antiquity.

While designing buildings in Great Britain, during which time my wife and I had our first daughter, I drew an ink sketch of a very old street scene in Rye, Sussex, and sent copies as a birth announcement. Favorable reactions from people who saw this drawing encouraged me to continue sketching in pen and ink using the flexibility of the crow quill. Even though as an architect I used the barrel pen for drafting, the love of the flexible nib stayed with me.

It is my hope that you too will begin to enjoy the magic of using the flexible nib to produce art. Do not fear the pen. Every artist develops their own method of using the pen so do not hesitate, in fact I encourage you, to copy different artists that you like. Though some of the illustrations in the book look complicated, do not panic. Once you learn the basics and are not afraid of the pen, you will produce spectacular ink drawings.

So…happy sketching!

RYE, SUSSEX
INDIA INK ON PAPER
9½" × 12" (24CM × 30CM)

1 GETTING STARTED

Pen and ink with watercolor can be done almost anywhere. All you need to look for is a small space to designate as your studio (doesn't that sound professional?), a comfortable chair or stool, reasonable light, and a few simple materials. For those…

You get to go shopping! You can find the basics at your local art store or online. See pages 80–82 for watercolor supplies. Become familiar with your materials, practice with them, experiment with them and you will become a confident pen-and-ink artist. The happiest artists are those who are not afraid to experiment.

Artist at Work

Crow Quill Pens

The first order of business in becoming a pen-and-ink artist is to choose pens. In olden times you didn't have the privilege of choice in writing or drawing devices. Quill pens and pens made from reeds were used for centuries. In the pages to follow, you'll learn to use crow quill pens. The name "crow quill" is used to designate the type of *nib* (the tip of the pen) that is used in producing pen-and-ink artwork. Crow quill pens consist of a

nib and pen holder and are referred to as dip pens because you actually dip the pen nib into a bottle of ink. There are also technical ink pens that have a self-contained ink supply. As I said in the introduction, I feel you lose flexibility with the technical pen, so we'll focus on the crow quill.

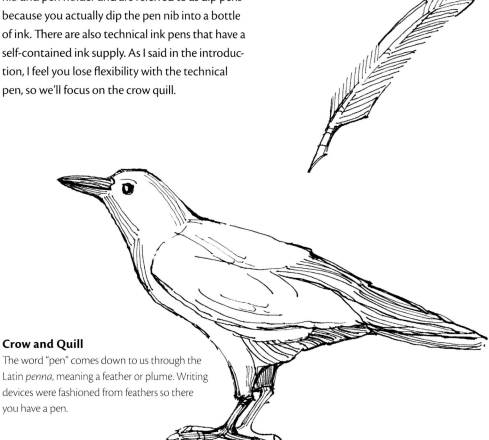

Nib Safety

- Do not lay your pen on a surface where it can roll off the table and fall to the floor. It will always land on the nib rendering it inoperable.

- Keep a container, such as a glass or a cup that will not tip over easily, to place your pens in so they are easy to reach.

- Be careful not to stab yourself on a sharp nib sticking out of the container.

Crow and Quill
The word "pen" comes down to us through the Latin *penna*, meaning a feather or plume. Writing devices were fashioned from feathers so there you have a pen.

PEN HOLDERS

The crow quill pen holders I recommend are cylindrical in shape and are approximately five inches (13cm) long. They are made in three basic materials: wood, plastic and aluminum.

Wood and plastic holders work about the same. Aluminum holders have an adjustment that allows the use of different sizes and shapes of nibs. Aluminum holders are also etched where you hold the pen. That allows for a better grip and holds the nib more securely than the other two.

NIBS

Crow quill nibs come in various sizes from #100 for very fine work to #108 for stiffer drawing. Most of the pen-and-ink work in this book will be done with a #102 nib. A great place to store your pen holders and nibs is in a clear plastic box that is compartmentalized (see page 17). Empty 35mm film containers are good to store nibs. Be careful that storage is not subject to moisture as the nibs can rust. Clean the nibs with a paper towel to remove ink or wipe after inking while still in the pen holder.

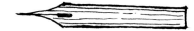

Nibs

Pen Holders and Nibs

Nibs are very delicate. Be careful not to damage them or your ink won't flow properly. Keep several of the same nib on hand, as inevitably a nib goes bad while sketching.

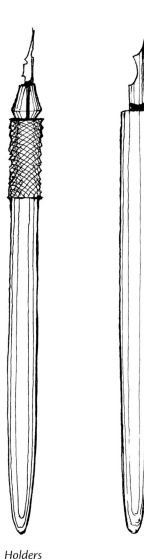

Holders

Inks

India ink is a generic term for a lamp black or carbon black ink. It can be thinned with water, yet it dries to a permanent, insoluble film. It is important to purchase only inks that are insoluble in water so the lines will not smear when applying watercolor. I use Higgins and Pelikan brand names. Koh-I-Noor also has some fine inks. You can use regular black ink, though, as long as your artwork will not be exposed to moisture.

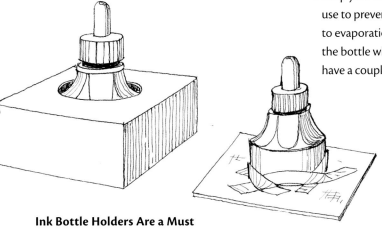

Ink Bottle Holders Are a Must
Whether you make your own with a piece of cardboard and tape or purchase one, you need a holder to keep your ink bottle from moving around while you work.

KEYS TO INKING

No matter what else you do, following these simple rules will make your experience with pen and ink more enjoyable.

- Use the same type of ink on any single drawing or series of drawings, as not all inks dry the same. You don't want the same drawing to have two or three different shades of ink.

- Keep your ink bottles corked when not in use to prevent the ink from thickening due to evaporation. (Just place the top loosely on the bottle while you're working.) It's best to have a couple of bottles going at one time.

Use a new one for finer lines, saving older inks for brushwork or work with larger pens. Label all your inks with the date of purchase, as inks will dry out over time.

- Use bottle holders. Ink bottles can easily be spilled, especially if you are working in a limited space. To avoid this calamity, bottle holders are a must. You can easily fashion your own from cardboard and tape. Or, if your budget allows, you may also purchase a holder from any art store.

India *Refillable* *Colored*

You Have Lots of Ink Choices
You'll need traditional India ink or something like it for crow quill pens. Refillable ink is used primarily for technical pens. Ask your art supplier for advice on brands.

Drawing Surfaces

The qualities to look for in a drawing surface are smoothness and firmness. This allows for easy use of eraser or knife for corrections and keeps you from tearing the paper or blotting ink. Some of the acid-free bond papers of heavier weights and better grades will meet these specifications. Bristol board and Crescent hot-pressed illustration board work also and have very smooth surfaces.

I like Crescent no. 215 hot-pressed illustration board. It's a medium weight, professional grade board. Its bright white surface provides greater contrast with pen and ink and transparent washes.

The smooth, hard surface of Paris paper is convenient and economical alternative to boards. Brilliant white, crisp and bleedproof, it is the ideal surface for detailed illustrations rendered for reproduction using crow quill pens, broad drawing pens, copperplate calligraphy or technical fountain pens.

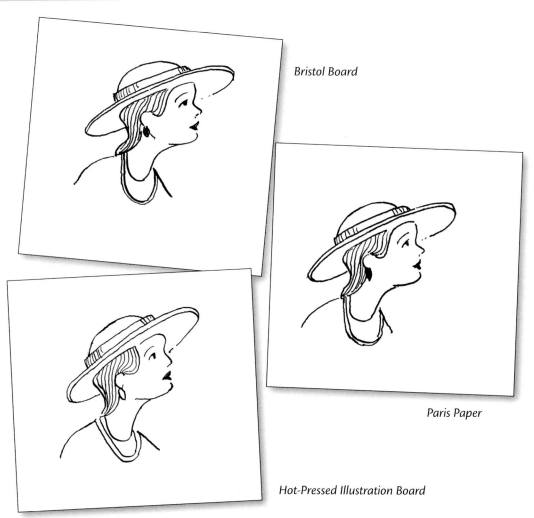

Bristol Board

Paris Paper

Hot-Pressed Illustration Board

OTHER SURFACES

In addition to the aforementioned papers and boards, there are, of course, other surfaces available that will take ink well. Usually, surfaces that are good for writing on with a regular pen will be satisfactory to draw on with a crow quill pen.

Tracing papers of stiffer grades can sometimes be used. Use this type of paper with caution, though. It's easily pricked through and erasing is rarely successful.

Tinted papers and boards can be used, too. Drawings can even be colored inks on black or very dark colored papers. As you learn the various techniques in this book, let your creative juices flow and your imagination go wild!

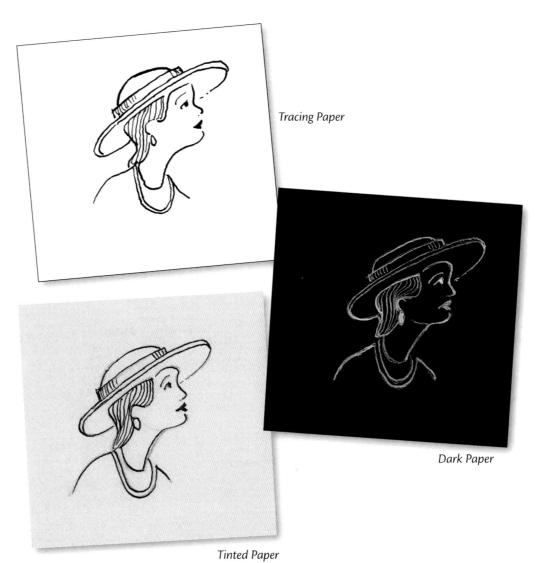

Tracing Paper

Dark Paper

Tinted Paper

Additional Supplies

Once you've got your pen, ink and drawing surface, just a few more items will complete your supply shopping spree. Pictured on these two pages are a plethora of items that will complete your studio. Also look for *artist's tape*, an opaque white, smooth, acid-free tape that's useful for holding artwork to drawing boards. It peels off easily without leaving a residue and is easy to write on. Keep *paper towels* and *disposable wipes* around for cleaning pen nibs, ink spills and to keep your hands clean. And, of course, get a few *sketchbooks*. Make sure they're acid free with smooth surfaces for lots of sketches. Spirals work best as they can be folded over to allow for easier sketching. Choose whatever size you're comfortable with.

Erasing Shield

An erasing shield allows you to erase without disturbing adjacent lines. I prefer a metal architectural erasing shield with a square edge.

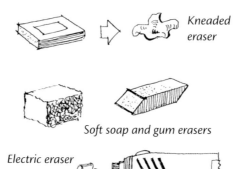

Kneaded eraser

Soft soap and gum erasers

Electric eraser

Erasers

Erasers are a must. A kneaded rubber eraser kneads easily into any shape, erases cleanly and picks up all residue. It's excellent for removing smudges. Soft soap and gum erasers are also good. I use an electric Sakura cordless eraser much of the time because it gets into small places and helps prevent crinkling of tissue tracing paper. It is compact and easy to use with an erasing shield.

For really tough jobs, a carefully wielded razor blade will often work.

Brush

You need a very soft horse-hair brush to brush away eraser crumbs.

Pencils and Sharpeners

Pencils, 2B or softer, can be used for laying out your subject matter before inking. The soft pencil can also be used to do value sketches. Mechanical pencils are useful because they eliminate the need for sharpeners.

Ballpoint Pens

Any kind of ballpoint pen collection can be used for doodling.

Pen and Nib Storage Case

A pen and nib storage case is any small, clear plastic box about 7" x 3½" x ⅝" (18cm x 9cm x 2cm) deep that protects the contents and allows you to see inside the closed case.

Pen and Pencil Holders

Pen and pencil holders can be made of anything—glass jars, glasses or cups. Store your pens with nibs upright. Make sure the containers are heavy enough so they don't topple over.

Magnifying Glass

A magnifying glass is very helpful when small work is required. I use an optivisor to keep my hands free.

Straightedge (T-square) and Plastic Triangle

The straightedge (T-square) and plastic triangle come in handy to keep lines square and to draw guide lines.

Tackle Boxes

Get tackle boxes in two different sizes: a large one to store all your art supplies and a smaller one to easily transport supplies on field trips. Look for one that has a couple of trays and is waterproof.

Tracing Paper

Tracing paper is perfect for sketches, preliminary detail renderings, quick roughs, and cutting and pasting. I like Bienfang Canary sketching and tracing paper. It's a light-weight roll paper that's popular with artists and designers. Almost any will work though.

Penciling Tip

Don't press too hard as you create your pencil drawings or you may damage the drawing surface and leave indentations.

Where to Draw

The most important task in finding somewhere to draw is finding a peaceful, quiet area just large enough for you, your art materials and comfortable seating. Keeping your materials organized is essential to keeping your creative juices flowing so you don't have to interrupt your thinking to find something.

If you are fortunate, you will have access to a professional drafting or drawing table in a specific room or area. If not, be of good cheer as any ordinary table, desk or writing surface in a shared area of your home will do. If you are using a multipurpose area I again suggest purchasing a tackle box or carrying case large enough to store all your materials.

If you have a north-facing window, set your materials up there. North light provides an indirect, more constant light. Floor and table lamps are suitable alternatives. I use a combination fluorescent and incandescent light. Fluorescent light is a cooler light than incandescent light, which is generated from an ordinary light bulb.

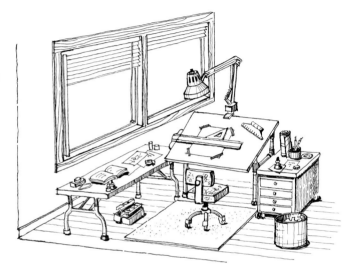

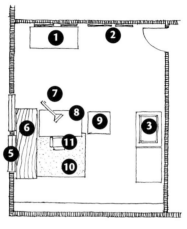

Create an Efficient Workspace Plan

Setting up your workspace in a U-shape with layout table, drafting table and a chair that can roll provides a very efficient way of working. You can easily get to everything without having to get up all the time.

1 Moveable table for still life, TV, etc.

2 View drawings on wall

3 Light table over flat file where original drawings and prints can be safely stored

4 Reference books

5 North light, if possible

6 30" × 8' (76cm × 1.4m) layout table

7 Adjustable light

8 3' x 5' (.9m x 1.5m) drafting table

9 Rolling cabinet with art supplies

10 Chair mat

11 Rolling Chair

Sketching Outside

Sketching nature can become one of your most exciting and fulfilling experiences. Your sketchbook will become a pictorial journal of your travels. Remember to put a few notes and dates on your sketches to remind you of how you felt and what your eyes saw.

The easiest way to sketch outside is to use a sketch pad or notebook with a 2B pencil or ball-point pen, returning later to your inside workspace to finalize your drawing with pen and ink. If you always carry these simple materials with you, it will be possible to capture an interesting scene anywhere you travel.

If it is a planned art outing, you may want to bring along a Masonite board to tape your paper to and a tote or tackle box to carry all your other supplies. And please don't forget your camera. Taking pictures will capture the exact light and composition that caught your attention. Then you will have a reference when returning to your studio.

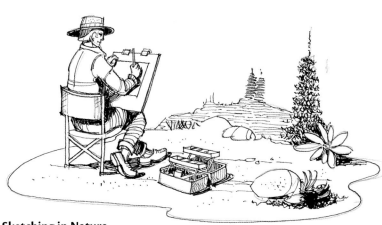

Sketching in Nature
Keep a portable stool in your car all the time. That way, you're ready at a moment's notice if you see a good sketching opportunity.

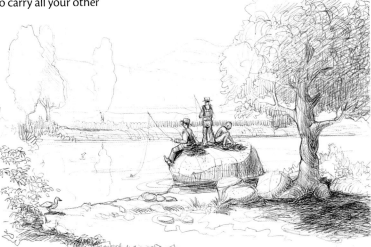

From My Sketchbook
One day I spotted some kids sitting on a rock, fishing. As I watched the little fishermen having a wonderful time, I decided to sketch the moment. As an artist, you can capture scenes like this and turn them into little stories for others to enjoy. You become a type of storyteller with scenes all around you waiting to be told.

Warm-Ups

Before beginning any drawings it's a good idea to do some doodling with a pencil or ballpoint pen to loosen up your sketching hand. This is similar to stretching before running or warming up before playing an instrument.

Always carry a ballpoint pen and pencil so you can doodle on napkins and scraps of paper. I even use margins in books I am reading. You will find your skill at drawing improves by doing this.

Doodle to Get Ready
Doodling like this before starting an ink sketch will help loosen up your fingers and arm for better control. It doesn't matter what you draw; let your mind wander. Remember objects you've seen throughout the day or look around you for subjects.

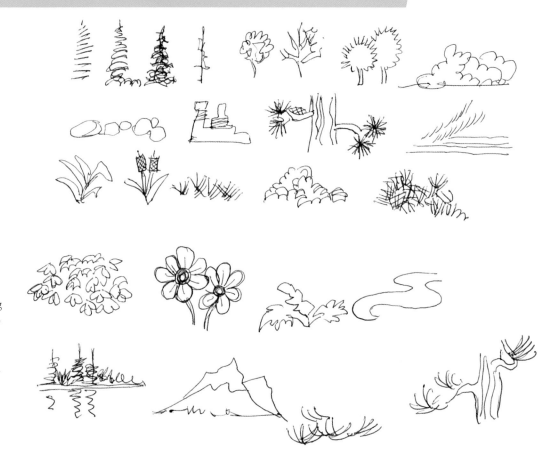

Holding the Crow Quill

The pen holder is designed to be held like a pencil, but pen handling is a little different than using a pencil. Getting the feel of the pen with a loaded nib of ink takes a little practice but isn't difficult. Very soon it will feel natural to sketch with a loaded pen.

Keep the Ink Flowing

If the ink does not flow readily as you practice, just slightly dip the nib into water before loading with ink.

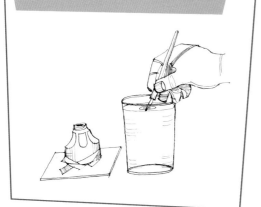

Don't Do This

Don't strangle the pen or grasp it too tightly like you might when holding a pencil. It doesn't allow the versatility of line work and may cause you to gouge the drawing surface.

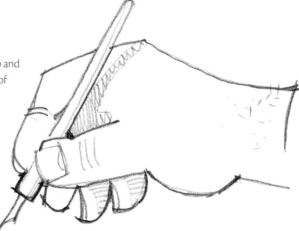

Do This

Hold the pen lightly between your thumb and forefinger. This gives you the best control of the pen and forces you to allow the ink to slide across the drawing surface.

21

Loading the Crow Quill

Loading the pen with ink is actually pretty easy. You just lightly dip the nib into the bottle of ink or place a drop into the nib with the dropper.

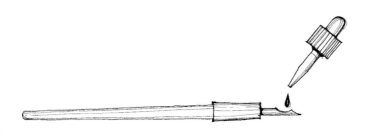

Don't Use Too Much Ink

Dip your pen into the ink bottle or, with the dropper on the ink cap, place a drop of ink on the bottom side of the nib. Not too much or the ink may drop off onto the paper.

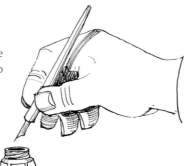

Use a Protective Sheet of Paper

A protective sheet of paper is just a scrap paper meant to protect your drawing from becoming smudged as you work. Always get your protective sheet in place before you begin to draw. You don't want to smudge your drawing, and you want some protection in position in case you accidentally drip ink.

Using the Crow Quill Pen

WHAT YOU NEED

- Sketchbook
- India Ink
- Crow quill nib and holder (any size)
- Protective sheet

Now that you know how to hold and load your pen, it's time to start using it. If you want to become a good pen-and-ink artist you should practice like a musician practices. These exercises will help you on your way to drawing the way the Old Masters drew. These lines will become the building blocks to producing fun pieces of art.

Hold the pen lightly, just firm enough for control. You should be able to move the ink-loaded nib in any direction without gouging the drawing surface. You want to feel the pen nib gliding over the surface in any direction without the point digging in and spoiling your stroke. Use drawing surfaces that are very smooth to make this easier.

Follow the examples to complete these exercises.

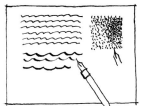

Waves and Dots

Hold the pen very lightly as you start making little waves. If you press down too hard, you'll gouge your paper. After you've filled up a page or two with waves, practice making simple dots (called *stippling*). Place dots close together to make things darker, and farther apart to make lighter tones.

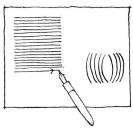

Horizontal Parallel Lines

Start off just making horizontal parallel lines. Once you get comfortable, try bending the lines as shown on the above right.

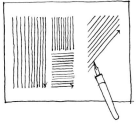

More Parallel Lines

Move on to vertical and diagonal lines. Pull your pen in only one direction at a time.

Varied Pressure

Practice making lines of different widths by varying the pressure on your pen.

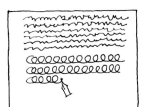

Scribbles and Loops

Fill a couple pages in your sketchbook with each of these. Lines of scribbles and loops will get you really comfortable and force you to develop a light touch.

Line Practice

WHAT YOU NEED

- 9" x 12" (23cm x 30cm) smooth bristol board or other smooth surface
- India ink
- #102 crow quill nib and holder
- 2B pencil
- Protective sheet
- T-square
- Triangle

A pen-and-ink sketch is nothing more than many lines and/or dots arranged in interesting ways on a drawing surface. Follow these simple rules as you practice making lines.

- Place a sheet of paper under your hand to protect your drawing from smudges.

- Work from left to right to prevent smudging.

- Don't hold the pen too tight.

- Turn the sheet around for control if you need to.

These exercises will further develop your feel of how to hold your pen and how much pressure to exert for different flows of ink and line variety. This line practice can be used on napkins, scraps of paper or even the phone book cover.

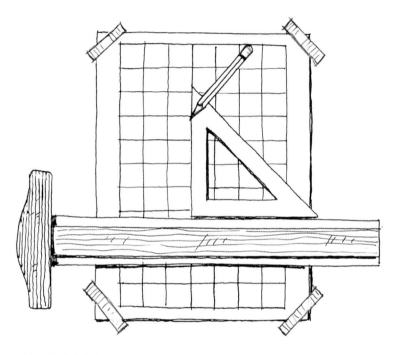

GET READY

On your sheet of smooth bristol board or other smooth surface, draw 1-inch (25mm) squares with 2B pencil using your T-square and triangle. These squares will act as borders for your line practice.

24

2 PRACTICE LINES

Use a #102 nib. Holding the pen lightly, practice drawing horizontal lines, then vertical lines to get a feel for the pen. Eyeball the lines rather than using a ruler to draw them. Once you've finished those, move down the boxes until you have tried all the lines shown.

1 *Horizontal lines*

2 *Vertical lines*

3+4 *Diagonal lines*

5 *Parallel curved lines improve your control*

6 *Varied pressure creates thick and thin lines*

7 *Horizontal lines with breaks and dots*

8 *Vertical lines with breaks and dots*

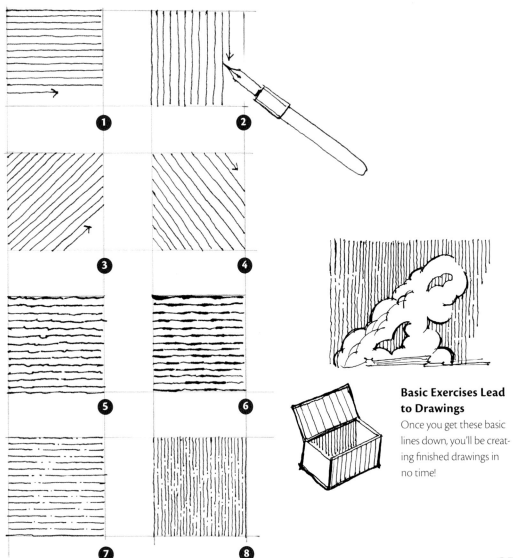

Basic Exercises Lead to Drawings

Once you get these basic lines down, you'll be creating finished drawings in no time!

25

Curve Practice

WHAT YOU NEED

- Sketchbook
- India Ink
- Crow quill nib and holder (any size)
- 2B Pencil
- Protective sheet
- T-square
- Triangle

Now that you've had some practice drawing straight lines, it's time to build some curves into your work. Lines are important, but people and landscapes are filled with curves and rounded corners.

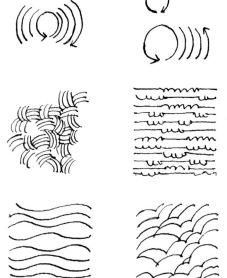

Make another grid for yourself like you did on page 24, then fill at least one row of squares with each of these strokes.

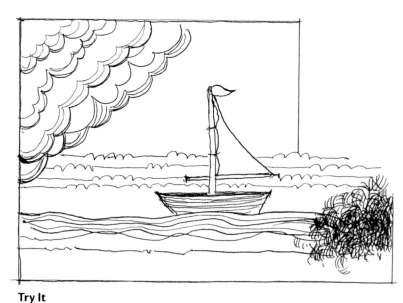

Try It

Use the strokes and lines you've practiced in the last two exercises to draw this simple sailboat scene.

Drawing Basic Shapes

Draw the triangle, circle and square in two dimensions. Practice drawing them in different proportions, using some of the curves you practiced here and the lines you practiced on page 25. Be brave! Practice the curve strokes that are usually the hardest.

Circle Tip

When drawing a circle, it is best to use a pencil with template or compass first, then freehand it in with your pen using the curves you did on curve practice.

Having had some practice in drawing lines to become familiar with the attributes of the pen, now is the time to practice using these lines on simple forms such as this egg and pyramid.

What to Draw

Sometimes you will have a flash of inspiration, while at other times you will scratch your head trying to come up with something to draw. Your best drawings will be of subjects, whether real or imagined, that are of interest to you. Some subjects really show better in ink and watercolor than others, too. Old buildings and landscapes are everywhere wanting to be sketched. Sketches of people require more practice, but when mastered you will be able to sketch anything. As you become more accomplished in drawing scenes you see or photograph, you will be able to draw upon your imagination to produce interesting drawings. It is important to sketch every day with pencil, ballpoint pens and ink.

Keep your big and little sketchbooks handy. Don't throw away your quick sketches and studies. Keep them for references and to show how you have progressed.

OLD FAITHFUL INN
INDIA INK ON BRISTOL BOARD
17" X 24" (43CM X 61CM)

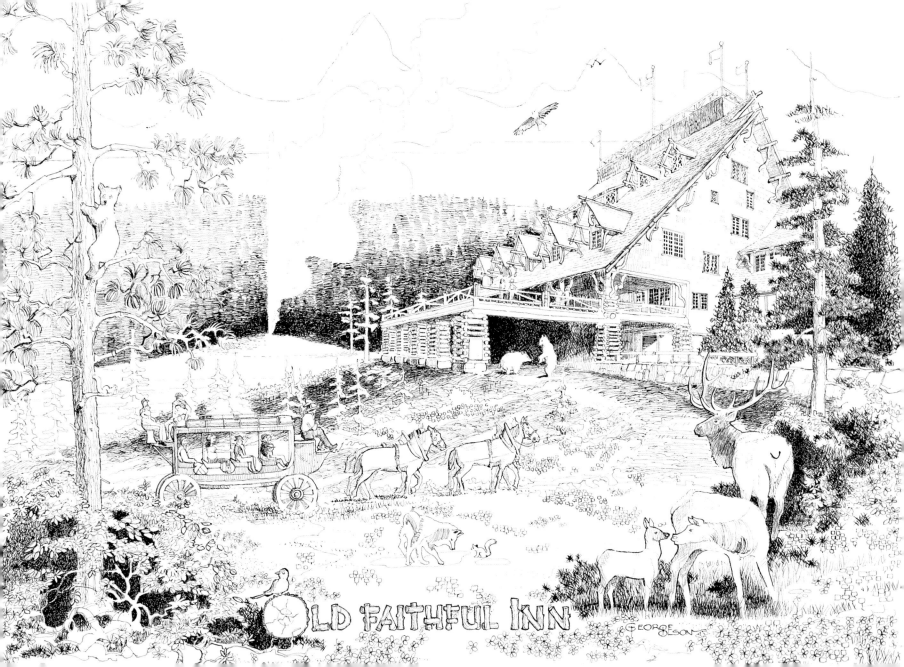

OLD FAITHFUL INN

GEORGE OLSON

Proportion and Perspective

It is important that you learn to sketch what you actually see in the correct proportions and with good perspective. Studying anatomy can help with human proportions, but, if you learn to sketch what you see, you won't need a class in anatomy. Likewise, while there are entire books on how to draw using perspective, a few simple tricks can simplify this process.

Proportion is basically the relationship of shapes to each other. *Perspective* is drawing those shapes to show the correct depth and distance.

As you view objects they visually become smaller the farther they are from you. All drawings have what is referred to as a *horizon line* that establishes where the eye level is. (Think of looking down a straight road or highway.) The trick is to make sure all the lines in your subject correspond to the horizon line you've established.

These can be calculated very accurately. But a wise old architect said to me once, "George, don't worry about methodically laying everything out. Eyeball the subject and the art will be almost as accurate as using the complicated methods." So, I'll share with you a couple of my favorite tricks.

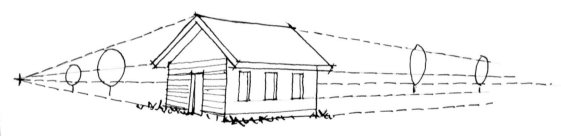

Using the pencil measuring technique will automatically lead you to correct perspective

All Lines Lead to the Vanishing Point

A *vanishing point* is a point along the horizon line where all other lines converge. In this example of two-point perspective, there are two vanishing points along the horizon line, one on the left and one on the right. Notice how you can see along two sides of the house, the front and the side?

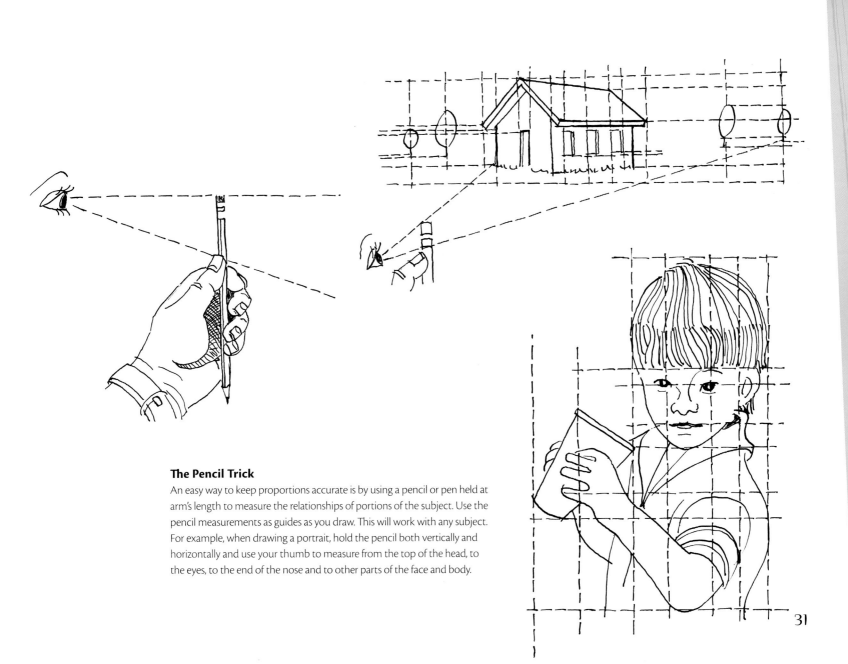

The Pencil Trick

An easy way to keep proportions accurate is by using a pencil or pen held at arm's length to measure the relationships of portions of the subject. Use the pencil measurements as guides as you draw. This will work with any subject. For example, when drawing a portrait, hold the pencil both vertically and horizontally and use your thumb to measure from the top of the head, to the eyes, to the end of the nose and to other parts of the face and body.

31

Equipment for Reference Photos

Using photos for reference is an excellent way to learn to sketch. Take pictures of landscapes, people, buildings and animals. If you don't have a camera, purchase a disposable one. Some of the disposable models available now produce excellent images.

If you have a digital camera and a computer, you can print the photos to whatever size you want that will fit on the print paper. You can also remove distracting details digitally or move them around.

I use a digital video camera from which I download stills to use as reference photos. This is absolutely terrific for moving objects.

Your Camera

Buy a digital camera with as high a resolution as you can afford (6MP or better). Think about the composition of your drawing as you photograph. Visualize in your mind how your subject will look as an ink sketch.

Disposable Camera

Disposable cameras come in a wide range of prices. Some even have zoom lenses. It is better to pay extra money to get one that gives you more control.

Tripod

Use the tripod when photographing objects with a telephoto lens, in low light or if you have a tendency to be shaky.

Digital Photos

You can view digital photos on your computer monitor so you can reduce or enlarge easily.

Digital Video

With a digital video camera, you can film and then download stills. This is extremely handy when you want to draw a running animal, such as a horse. You can download the images one at a time and see the position of the legs, tail, etc.

Using Reference Photos

Go through your small photos, choose the ones you want to use and have them blown up to 5" × 7" (13cm × 18cm) or larger. If you have a digital camera, you can enlarge the photo right on your computer and print it out.

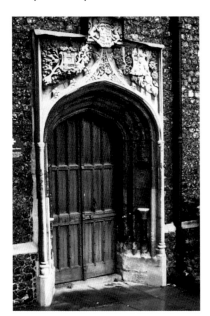

Reference Photo

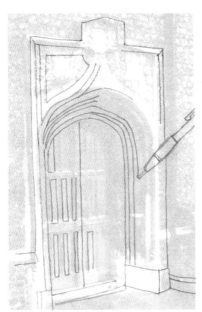

Place Tracing Paper Over the Enlargement

Lay tracing paper over your enlarged print and trace a simple outline drawing over your subject that you can later transfer to your inking or painting surface.

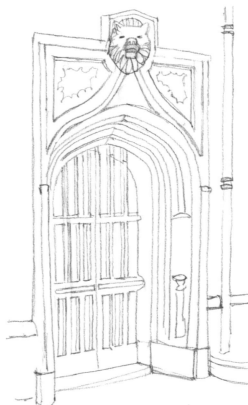

The Outline Drawing Need Not Follow the Photo Exactly

Don't be a slave to your photograph. Move the subjects around or even eliminate some of the details that are distracting. Incorporate subjects from other photos. You are not trying to duplicate the photograph—just using it as a reference.

Working from Reference Photos

Keep a photo file of anything you might want as reference for a future sketch. A word of caution, though, when using photographs. The camera does not always see what your eye does in shadows and certain lighting conditions. Take notes so you will remember certain aspects of the subject while working in the studio. And use your photo as a reference only! Do not become a slave to it. Pick and choose what you need from the photo that will enhance your sketch.

WHAT YOU NEED

- Paper for inking (any kind)
- India Ink
- #102 crow quill nib and holder
- 2B pencil
- Kneaded eraser
- Protective sheet
- Tracing paper

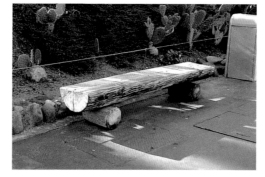
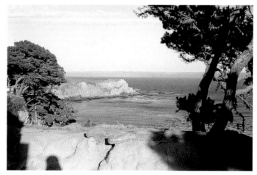

Reference Photos
Take elements you like from your reference photos; don't feel compelled to copy the photos verbatim. I thought my photo of the coast would make a nice sketch, but it needed something in the foreground. I found the photo of the log bench in my files and it seemed like a good solution.

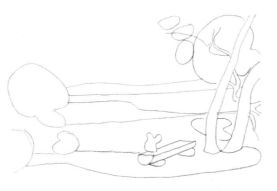

1 CREATE AN OUTLINE DRAWING
Use tracing paper and your 2B pencil to trace the coastal scene. Sketch in the log bench freehand. Rework the bench until its proportions look correct. Sketch in a simple shape for the squirrel. Transfer your basic sketch to your inking paper once the details are worked out.

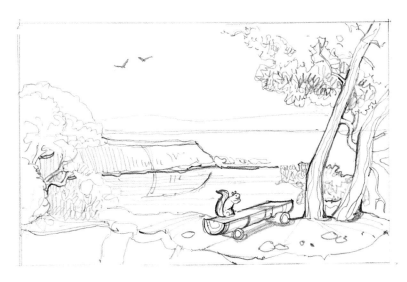

2 TRANSFER YOUR OUTLINE TO YOUR DRAWING SURFACE AND ADD DETAIL

The detail you add to the outline sketch will prepare you for the ink sketch. Pencil strokes such as the ones in the tree foliage and tree bark will inform what you add with ink. The big difference is that pencil's erasable!

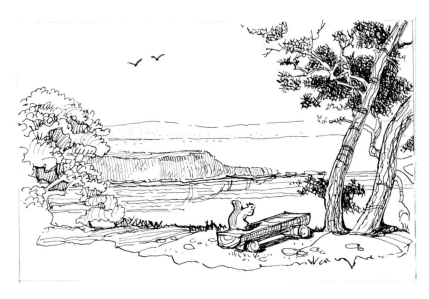

3 ADD INK TO FINISH

Use your pencil marks as guides as you ink. You don't have to follow your pencil marks any more than you have to follow the reference photo exactly, though. Notice I added dark crosshatching to the tree foliage to make the tree trunk show up better (not in the pencil drawing). And I added some reflections to the water (not in the reference photo).

2 BASIC PEN & INK

Now that you have become a little more familiar with the pen, you're ready to begin making more advanced drawings. Pen and ink was used by the Old Masters as studies for paintings until it came to be recognized as a form of art itself. It was used to illustrate catalogs, books and magazines before photography became more dominant. Ink sketches can be appreciated not only as a means of creating art but the very nature of the pen strokes can be interesting in and of itself. Just as every person's handwriting is unique to them, so it is with pen-and-ink artists. You may copy another artist's technique for now, but you will soon develop your own style.

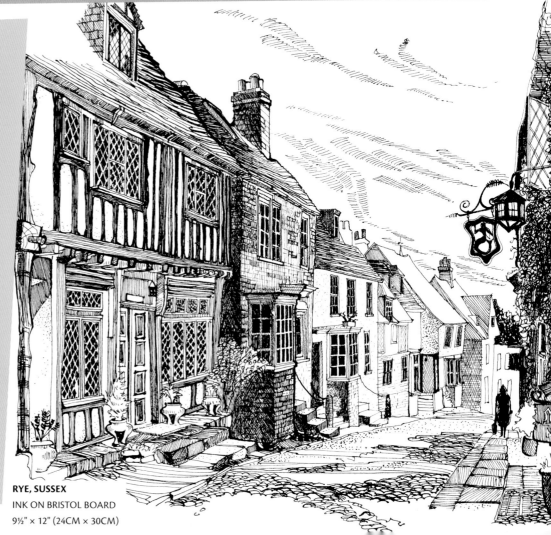

RYE, SUSSEX
INK ON BRISTOL BOARD
9½" × 12" (24CM × 30CM)

Basic Outline Drawing: Easiest Form of Drawing

In spite of the fact that we do not see things in outline form, it is more natural when drawing to think of objects as outlines rather than as shadows or values. Using a pencil to sketch an object in outline, as a basis for your drawings, allows for more control when you add in lines to produce the finished sketch with values and tones.

Because ink is so permanent, always do an outline drawing with a pencil first so you can easily alter and erase it without damaging the drawing surface. Practicing outline drawing with pen and ink is fun too though, and interesting art can result.

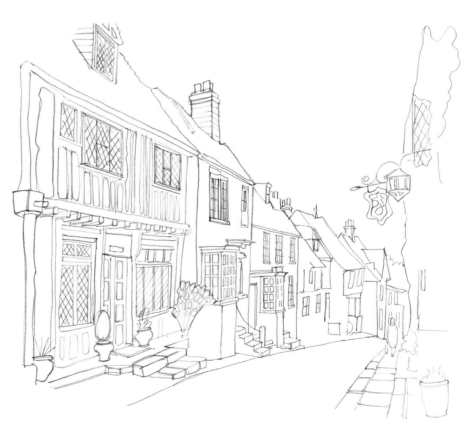

Outline Drawing of Rye, Sussex

The outline drawing helps to keep the buildings and street in perspective. Originally there were small cars on the street, but I eliminated them to better show the street's antiquity.

37

Outlines Begin With Simple Shapes

You learned in chapter 1 that you'll begin all your ink drawings with outline drawings. But what's an outline drawing really? An outline drawing consists mainly of simple shapes that make up any object. Anything you'll ever want to draw consists of easy basic shapes.

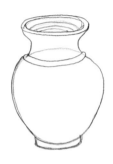

Concentrate on the Main Shapes

The main shapes in this vase are: the base, the body, the dark ring around the neck and the opening at the top. Just indicate these main shapes in your outline. Use a soft lead pencil and go over them several times if the shapes do not come out. Don't be afraid to use tracing paper to get the feel for the shapes, either.

Simplify Complex Shapes

The candleholder and candle seem complex at first. But if you think about their basic shapes, a cylinder and a circle, they are suddenly very simple.

Create an Outline Drawing

WHAT YOU NEED

- Tracing Paper
- 2B Pencil
- Kneaded eraser

Remember the "Using Reference Photos" section on page 33? That's exactly the technique you'll use to begin outline drawings.

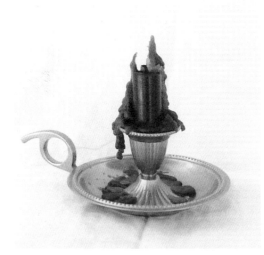

Reference Photo

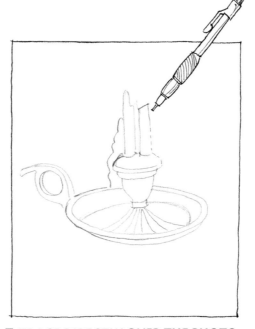

1 TRACE DIRECTLY OVER THE PHOTO
Place your tracing paper over the reference photo. Just outline the edges that show through.

2 COMPLETE THE OUTLINE USING BASIC SHAPES

Remember, you're only paying attention to shapes at this point. Go over the outline you made, simplifying it into basic shapes. The outline shapes will guide you as you go back in later to add texture and detail.

As you develop the sketch, rearrange shapes and lines as needed to prepare for the final drawing. I use an eraser sometimes to eliminate lines that distract me.

Enlarge or Transfer Drawings Without a Copy Machine

In getting ready to ink, you'll often want to make your drawings larger or transfer them to better paper. This is an easy trick to accomplish just that. Follow along as I enlarge this photo of my granddaughter, Maggee.

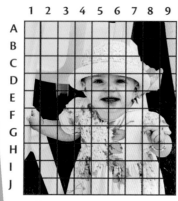

Reference Photo

Use tracing paper and a pencil or an ink pen to divide a copy of your photo or sketch into squares. Label the rows of boxes: A, B, C, etc. horizontally; and 1, 2, 3, etc. vertically.

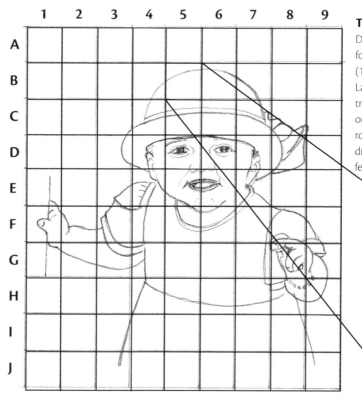

Transfer to a Larger Grid

Draw another grid, only double the size of your boxes for this one. So, if you made your first one using ½-inch (12mm) boxes, make this one using 1-inch (3cm) boxes. Label the rows of boxes on this grid also. Now you simply transfer to your larger grid the shapes you see in each box on your smaller grid using the numbered and lettered rows for easy reference. The proportions on the larger drawing will be quite correct. This is a great way to transfer any sketch onto any surface for inking or painting.

BOX 5B

Just looking at the shapes or lines in one box at a time makes it easy to transfer a drawing.

Develop Your Outline Drawing

WHAT YOU NEED

- Outline drawing from page 39
- Smooth paper for inking
- India ink
- #102 crow quill nib and holder
- 2B pencil
- Kneaded eraser
- Protective Sheet

Use the outline drawing you created on page 39 to practice adding detail.

1 REVISIT YOUR INITIAL LINES
Pencil over the tracing to strengthen the simple shapes even further. Transfer your completed outline drawing onto smooth paper for inking using the method on page 40.

2 ADD SHADING
The pencil is the thought process for the ink sketch to follow. Use the pencil to establish shades and textures.

3 ADD INK TO FINISH
Ink right over your pencil marks. If you want to change shading or line work from the pencil, go ahead; the pencil drawing is only a guide. Now's the time to add texture and detail to your drawing. After the ink dries, erase the pencil lines with a kneaded eraser.

Drawing Quickly With Freedom

WHAT YOU NEED

- Sketchbook
- Ballpoint pen

The idea in drawing quickly and freely is to not worry about making mistakes. Quickly block out a subject and use linework and squiggles to capture the essence of what you are drawing.

Copy the drawings on the following page, then go out and fill pages of your sketchbook with quick drawings of your own. Be free but controlled. Don't worry about lines overlapping. Have fun, let your mind wander. Don't worry about making mistakes.

This is sometimes easier using just pencil or ballpoint pen because they don't have sharp points that gouge the paper. When drawing freely with pen and ink use very smooth paper (white ⅛-inch [32mm] foamcore board is great as it is very smooth and supports itself). Drawing freely helps to train the eye to see correct proportions. (See page 30 for a refresher on using your pen or pencil as a measuring tool to learn the scale of objects.)

Your Sketching Options

Mechanical 5mm pencil with 2B lead is easy to carry in your pocket and doesn't need sharpening. The lead is narrow enough to simulate ink lines.

Black ballpoint pens are inexpensive, so keep one in your pocket all the time. It works on any type of paper.

A 2B wood pencil needs sharpening with a knife or a pencil sharpener.

Use crow quill pens lightly with free-flowing India ink when sketching quickly. These require very smooth surfaces.

42

Trees

Trees consist of different basic shapes depending on species. Sketch freely. Do not worry about overlapping branches and leaves. Use squiggly lines for foliage, shade, shadows and textures.

Clouds

Use the curved lines you practiced on page 26 to sketch fluffy clouds.

Veggies and Fruit

Use basic shapes to sketch most vegetables and fruit easily.

Flowers

Use ovals, circles, curved lines and parallel lines to make quick sketches of flowers.

Household Furniture

Exercise your skills drawing in perspective by drawing furniture around the house. This also forces you to practice with all the different lines.

Books

Practice your parallel and curved lines to sketch stacks of books.

Basic Values: Lights and Darks

Value is the relative lightness or darkness of a tone or color. Value change is what allows you to draw subjects to look three-dimensional. Because in ink work a line or dot is completely black and usually on a white background, lines and dots have to be placed close together in varying thicknesses or crossed in order to create different values. There are many, many ways and combinations of strokes to accomplish this.

VALUE SCALE

Value scales show the progression of lightest to darkest (or darkest to lightest) in a shade or hue. Becoming proficient at creating value scales will make creating finished pencil or ink drawings come as second nature to you.

Pointillism or Stippling

Placing ink dots at different spacing can be used to create very controlled tones. Stipple very lightly so as not to mar the surface of the paper.

Crosshatching

You can adjust the value by placing the lines closer together…

…or by adjusting their width by increasing or decreasing the pressure you apply to your pen.

Parallel Crosshatching

You can make the same sorts of adjustments to your parallel crosshatched lines.

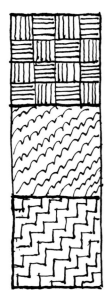
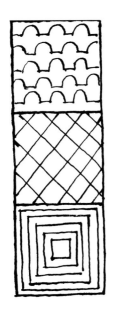

Different Ways to Create Value

Practice making value scales using these experimental strokes.

Experiment

Combine techniques to achieve value changes with added texture and creativity.

Basic Tone Building to Create Volume

WHAT YOU NEED

- Smooth paper for inking
- India ink
- #102 crow quill nib and holder
- Compass
- Protective sheet
- Straightedge

Understanding values and tones and how to use them in your drawings is probably one of the most important skills that you can master. As you saw in the value scales, there are an infinite number of values. To simplify it, think in terms of only four values, light to dark.

Using four values, you have the tools to draw any object realistically. And you can often use the white of the paper to represent the lightest values. Once you can accurately create changes in tone, you'll be able to give objects volume—so they'll look three-dimensional on paper. Here, you'll practice creating just four values using different line techniques.

Create a Tone Wheel

Using a #102 nib, draw a 1-inch (3cm) circle surrounded by twelve squares. Use a compass to get a true circle and a straightedge for drawing the squares. Begin at the right, making your darkest value using parallel lines (**1**). (Do not use a straightedge when drawing the straight lines.) Then make the lightest value using parallel lines (**2**). Fill in the values in between (**3** and **4**). Continue, sketching in the darkest first, then the lightest and filling in between. Squint your eyes to better see the difference in value changes.

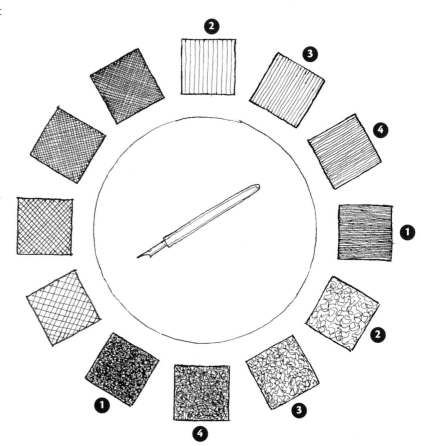

46

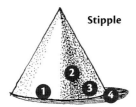

Stipple

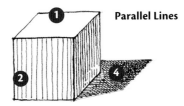

Parallel Lines

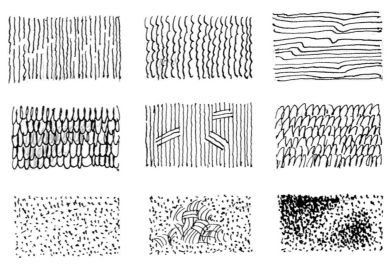

Four Values Create Volume

Lightly sketch a cone, cube and sphere.
Use the values you practiced on the
tone wheel to give these shapes volume.

Scribble

1 Light or Highlight—*Lightest part of any object.
This is where the light hits the object.*

2 Medium—*Areas of your object that are in neither full
shadow nor full light.*

3 Reflected light—*A light gray value along the edge that
separates the dark shadow on the object from the dark cast
shadow.*

4 Dark Cast Shadow—*Darkest value on your drawing. It is
opposite the light.*

More Ink Marks

Practice creating volume using
all these different ink lines and
marks. Then make up some
strokes of your own!

Combining Strokes Into Areas of Tonal Value

WHAT YOU NEED

- Smooth paper for inking
- India ink
- #102 crow quill nib and holder
- 2B pencil
- Kneaded eraser
- Protective sheet
- Tracing paper

The eye sees in contrasts. White on white, for instance, is invisible. To create contrasts you have to have differences in tone or value. Because of this, a credible drawing needs contrast for the viewer to see what you are trying to depict. You could create contrasting tones using the same strokes (all parallel lines, for example), but that would quickly become boring and wouldn't express the different textures very well.

You have a plethora of strokes to choose from when using ink; exploit them all to create something fun and interesting! Practice with this simple sketch of a mushroom fairy (you could create your own fantasy) and notice how the combination of the line direction, stippling, cross-hatching and even white space creates tones and values for contrast.

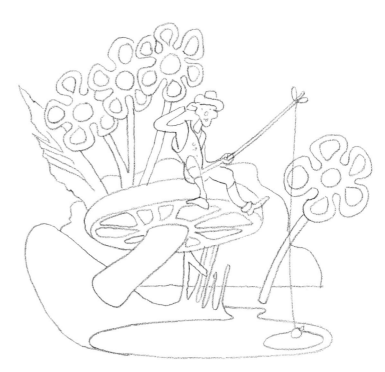

1 BEGIN WITH AN OUTLINE DRAWING
Use tracing paper to copy the basic shapes for this drawing.

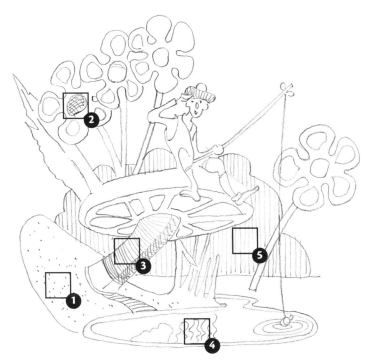

2 TRANSFER TO A PENCIL DRAWING

Using the method on page 40, transfer the outline to your smooth paper. Add details and lines to guide you as you add ink in the next step. Think about how you are going to apply your ink lines while you still have the freedom to easily erase. Don't overwork this stage.

 1 *Stippling*

 4 *Wavy lines*

 2 *Crosshatching*

 5 *Vertical lines*

 3 *Diagonal lines/ crosshatching*

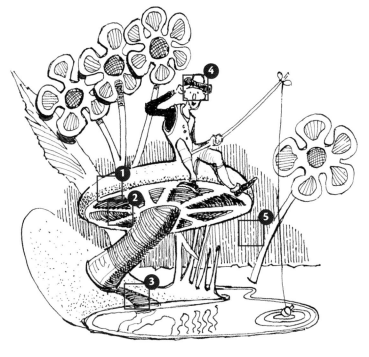

3 DRAW YOUR INK SKETCH DIRECTLY OVER YOUR PENCILS

Go over your pencils with ink. Develop shadows and details. Don't be a slave to your pencils; just use them as a guide. Once you're finished, allow the ink to dry *completely*. Then carefully erase any stray pencil lines.

 1 *Dots close together for the mushroom rim*

 4 *Nearly solid vertical lines for the fairy's hat*

 2 *Dark cross-hatching under the mushroom*

 5 *Broken lines for middle tones*

 3 *Thick parallel lines for the shadows*

Basic Textures

Texture is a way of identifying the surface of a material. Think of texture in terms of rough, smooth, hard and soft. Create textures using stroke techniques you've already practiced, using lines, dots or other strokes arranged in such a way as to enhance the surface of your subject.

How you draw texture depends on where the object appears in the drawing. Usually the center of interest has the most texture detail with backgrounds and foregrounds being simpler.

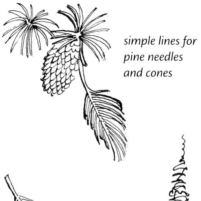

simple lines for pine needles and cones

Use Simple Techniques to Create Textures

You've already learned the techniques you need to create texture. See if you can identify the different techniques used to create these various textures.

Follow the form of the object. Use pressure on the pen nib to give variety to the line width. Use stippling to help give texture to stones. I use stippling randomly to help draw the different objects together.

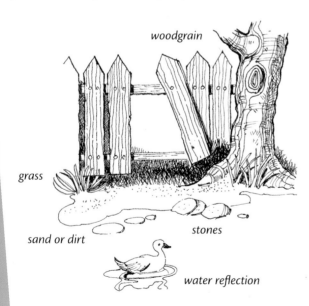

woodgrain

grass

sand or dirt

stones

feather

scribbles for an evergeen in the distance

cattails

metal and wood hammer

hair

crosshatching for burlap or screen

water reflection

50

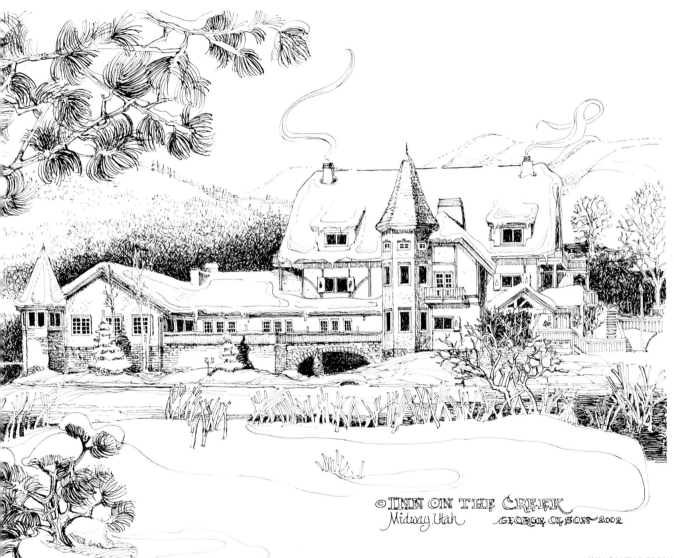

I used nearly every technique we've discussed to complete "Inn on the Creek." Pen and ink is mainly simple techniques, patiently applied.

© INN ON THE CREEK
Midway Utah GEORGE OLSON 2002

INN ON THE CREEK
PEN AND INK ON BRISTOL BOARD
11" × 13½" (28CM × 34CM)

51

Basic Composition

Composition is the way you place the objects in your drawings to create an interesting visual story. If the composition is done well, the viewer will find it interesting and will want to explore its contents. Learning the best way to arrange objects, their values and the values of the overall drawing can be a lifelong quest, but there are some simple rules of thumb.

- Avoid symmetry or placing your *focal point* (main subject) in the center of the composition. It divides the interest.

- Follow the *rule of thirds*. Divide your drawing surface into thirds. It is usually better to place the dominant subject of interest where the lines cross.

- Avoid objects that lead the eye off the page.

- Avoid lines and shapes that barely touch…it's better to overlap.

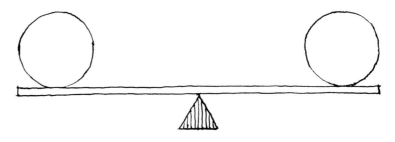

Avoid Symmetry in Shape or Value
Symmetry is usually uninteresting and boring. Remember this when placing focal points and values.

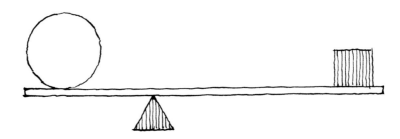

Asymmetry Is More Interesting and Provides Balance
The picture is still balanced, because the shaded small objects balance out the unshaded large one.

Not so good

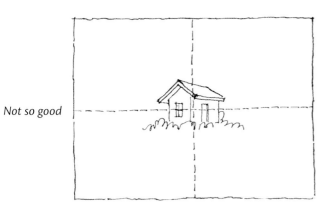

Avoid Centering
Do not divide your sketch into equal halves vertically or horizontally.

Best

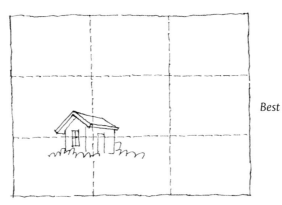

Use the Rule of Thirds
It's better to divide the sketch into thirds of equal space. Place the *horizon* (that line where you see the sky and the world meet) and focal point or points where the lines cross.

Not so good

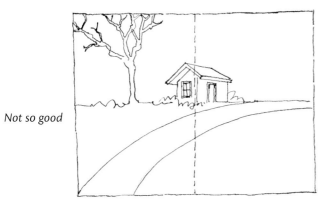

Avoid Lines That Meet at Intersections, Leading the Eye off the Page
The road not only leads the eye off the sketch in this picture, it also intersects directly with the lower left corner of the sketch. This divides the picture awkwardly.

Best

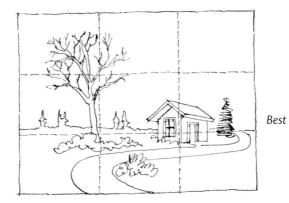

Keep the Eye Within the Picture
It's better to stagger lines as shown here. The road leads the eye to the focal point, the building.

53

Arranging Values to Create a Good Composition

You've already learned how important value is. The key to arranging values is to keep it simple, from dark to light. Combine a good value range with the rules of thumb illustrated on pages 52 and 53, and your art will positively sparkle.

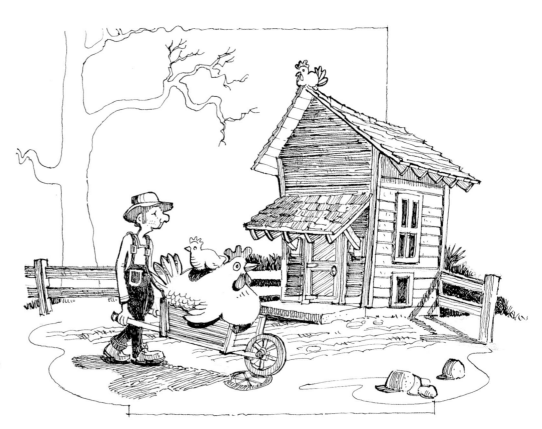

Use a Range of Values

The values here range from black to white and are arranged to keep the eye on the farmer and chicken. The farmer's black overalls help draw the eye. And the black that helps to pop out the building is just enough to give interest and tie the drawing together without detracting from the focal point.

54

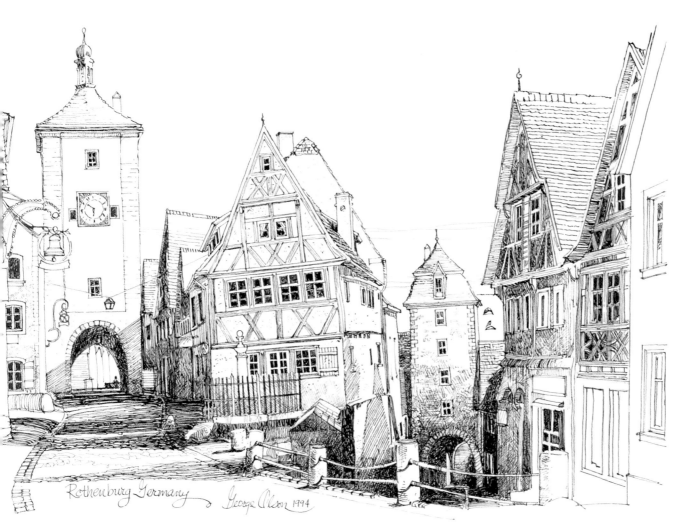

Rothenburg is a very, very old town and pen and ink is the perfect medium to express its antiquity. This is one of my favorite sketches.

Study the crosshatching to see how the shadow parts give depth and perspective all through value changes. Notice the path on the left that leads the eye under the arch in the background; the texture of the shingles on the roof to the right; and also how the posts in the foreground are expressed without tone as the shadows behind them define their shapes.

Rothenburg Germany *George Olson 1994*

ROTHENBURG, GERMANY
INDIA INK ON BRISTOL BOARD
13½" × 20" (34CM × 51CM)

Draw a Simple Building

WHAT YOU NEED

- Smooth paper for inking
- India ink
- #102 crow quill nib and holder
- 2B pencil
- Kneaded eraser
- Protective sheet
- Tracing paper

Pen and ink expresses buildings in a unique way from other media. It gives a feeling of history. This old church in Europe is simple but dramatic. I would love to have been the architect who designed it.

Use the different line and stipple techniques you have already practiced to sketch this building. Buildings have to show signs of aging. Try to feel the aging as you sketch this building. How many worshipers have passed through the chapel over the ages? Each subject you sketch has a story and the more you can feel it, the better story you will be able tell.

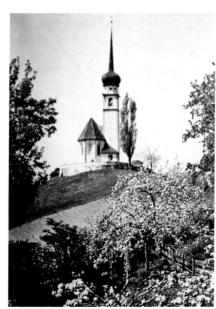

Reference Photo

1 CREATE THE OUTLINE SKETCH

Use tracing paper to create an outline sketch focusing on just the basic shapes and outside lines of the building.

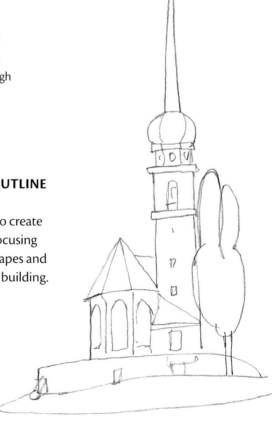

56

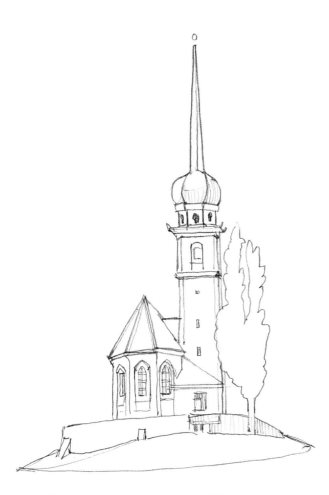

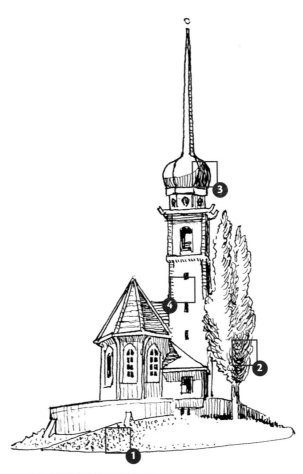

1 *Stippling for the grass*

2 *Quick, downward strokes for trees*

3 *Parallel lines on only the shadow side of the building*

4 *Leave the light side white.*

2 ADD DETAIL WITH PENCIL

Transfer the outline sketch to your inking surface using the grid method on page 40. Add some sparse details to guide your inking.

3 FINISH WITH INK

Ink over your pencil with a light hand. Remember, you're just using your pencil strokes as a guide.

Draw a Simple Portrait

WHAT YOU NEED

- Smooth paper for inking
- India ink
- #102 crow quill nib and holder
- 2B pencil
- Kneaded eraser
- Protective sheet
- Tracing paper

Because portraits are more difficult, you need to pay attention to proportion. Study the proportions of the facial features, hat and partial body before you begin.

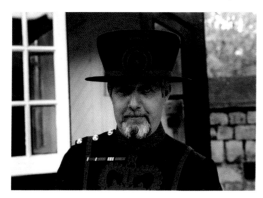

Reference Photo
While in England, my wife and I visited the Tower of London. A very colorful costumed group of men called yeomen wander throughout the complex helping tourists. One in particular was quite friendly to us and allowed us to take his picture.

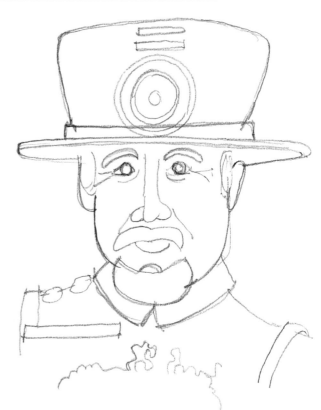

CREATE THE OUTLINE SKETCH
Just as you did to draw the building in the previous demonstration, trace over the photo to create an outline sketch. Even a face can be broken down into simple shapes.

58

2 CREATE THE PENCIL DRAWING

Transfer the outline sketch to your inking surface using the grid method on page 40. Add some sparse details to guide your inking.

1 Crosshatch to create the darker area of the hat.

2 Darken lines on the outline of the figure to punch it out.

3 Dark areas by collar help give it contrast.

3 ADD INK TO FINISH

Ink over your pencils with a light hand. Remember, you're just using your pencil strokes as a guide. As you work, imagine what the ink will look like when it is applied before you begin your strokes,

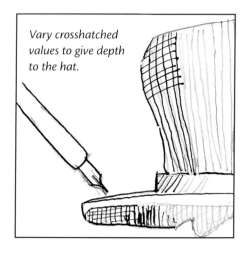

Vary crosshatched values to give depth to the hat.

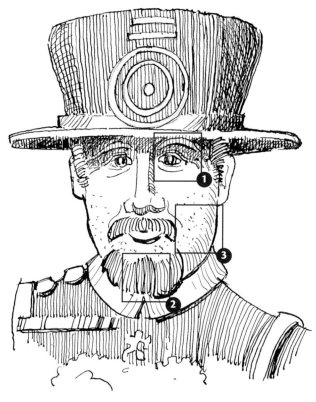

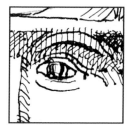

1 *Create eye shading with vertical lines spaced closer together.*

2 *Press harder on the nib to indicate the beard and moustache.*

3 *Combine parallel curved lines with scattered stippling for face shading.*

Draw an Animal in a Landscape

You'll use the same skills as in the previous demonstration—creating an outline drawing with simple shapes and adding details using simple strokes—to create this slightly more detailed drawing of an elk in the forest.

Most hoofed animals in the wild are similar in body structure. It is their proportions that differentiate them. By using simple shapes to create the overall proportions of this elk, it will become easier to add the details.

In this demonstration you'll use Paris paper to allow you to skip the transfer step. Paris paper is light enough to allow for tracing, yet still holds up well to erasing and inking.

WHAT YOU NEED

- Paris paper
- India ink
- #102 crow quill nib and holder
- 2B pencil
- Kneaded eraser
- Protective sheet

1 CREATE AN OUTLINE SKETCH
On a sheet of Paris paper, use a pencil to either trace or copy the basic shapes to create the outline sketch of this elk in the forest.

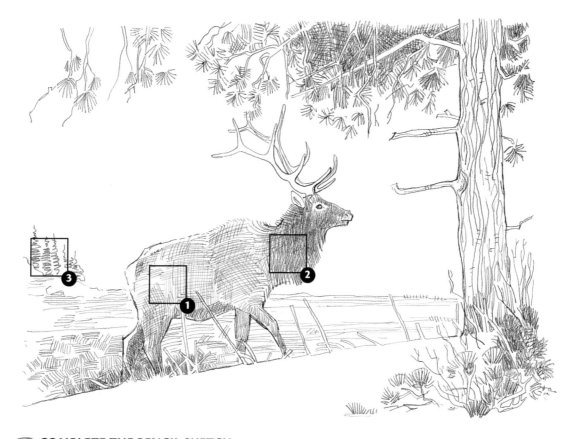

1 *Use simple crosshatching for the hide.*

2 *Layer parallel lines to create the dark value for the mane.*

3 *Fir trees in the distance are not quite so detailed.*

2 COMPLETE THE PENCIL SKETCH

Using the outline sketch, draw in more detail using strokes similar to what you will apply when adding ink. Use the freedom of the soft pencil lead to establish values and tones.

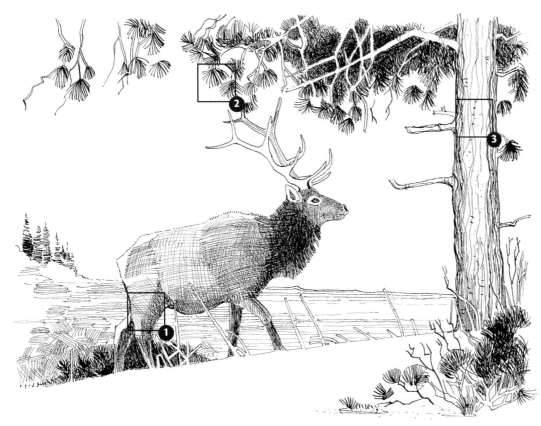

1 *Crosshatching for the shadow areas of the legs.*

2 *Pine needle patterns differ from distant firs.*

3 ADD INK TO FINISH

Lay the ink strokes following the pencil strokes. Do not become a slave to the pencil strokes, however. Just use them as a guide. Because the ink is much darker than the pencil, you will need to make adjustments as you apply it.

3 *Use rough lines and stippling to depict the tree bark.*

Draw a Detailed Landscape

WHAT YOU NEED

- 8" x 10" (20cm x 25cm) or 9" x 12" (25cm x 30cm) smooth bristol board
- India ink
- #102 Crow quill nib and holder
- 2B pencil
- Kneaded eraser
- Protective sheet
- Tracing paper

When first beginning to sketch landscapes, choose simple subjects: trees (winter is great for this because all the branches are visible), flowers, rocks and other objects. Remember, all these have individual characteristics that can make detailed drawings; e.g., each rock is different and trees are not all alike. Feel the individuality of each one of the objects in nature and your art will reflect it.

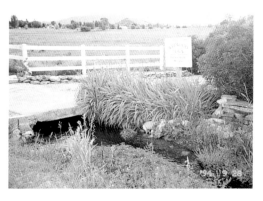 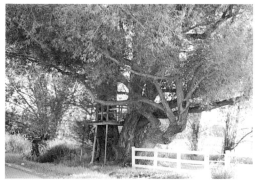

Reference Photos

I photographed this gnarly old willow tree and a stream with clumps of pampas grass while on a morning walk. I combined the two to come up with this composition. I knew I had to sketch the tree with its grandpa-like branches. You will get to recognize when sketching landscapes what subjects would make the best ink sketches.

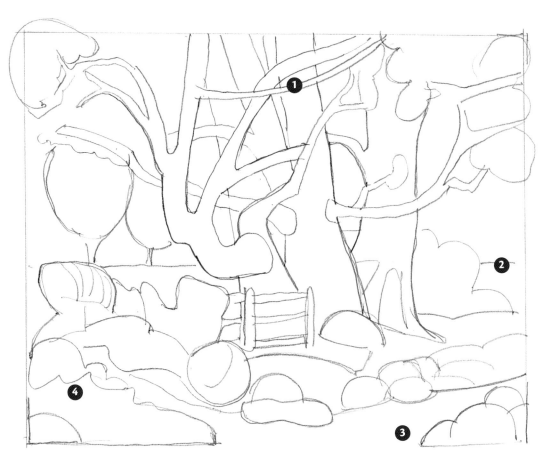

DRAW THE OUTLINE PENCIL SKETCH

Layout a rectangle on your bristol board and sketch the outline in pencil based on the photos to establish your composition. Use tracing paper to get the shapes right if you want to. Or, if you're feeling ambitious, sketch directly onto your inking surface. Basically, three tree trunks spring from the same source. The composition will be based on these vertical elements with all else subordinate to them.

1 *Most of this sketch is from the tree photo.*

2 *Horizontal line gives the sketch a base.*

3 *Make believe stream.*

4 *These shapes will become the grass clumps from the other photo.*

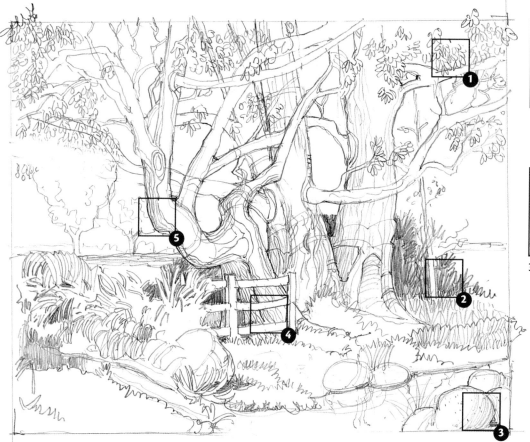

1 *You'll use these same squiggles for leaves while inking.*

2 *Indicate dark areas to help define the tree trunks.*

3 *Lines follow the curve of the stone.*

4 *Draw scraggly parallel lines for tree bark lighter than the edges of the tree.*

5 *Make darker lines at the edges of the trunks.*

2 MAKE A DETAILED PENCIL SKETCH

Continue with pencil sketch lines, mimicking the lines you plan to use when inking. Add dark areas in back of the tree and fence to pop them out. Add more visible branches to give the tree character.

Remember, you are the artist and can add or delete what you want. Draw over the pencil borders. This is your chance to change the photograph and give it an artistic feel. You can clean up later when inking.

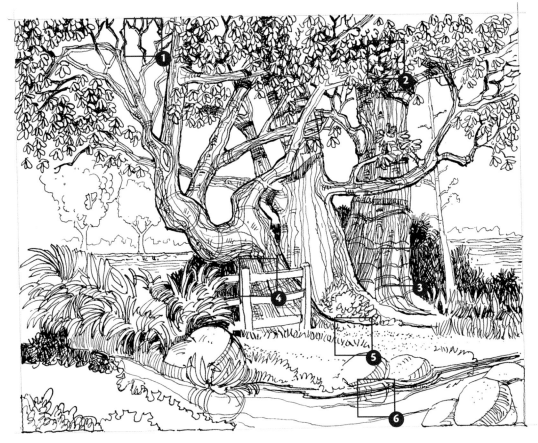

1 Add lots of little branches for interest.

2 Darken between leaves for depth.

3 Curved lines help show the roundness of the tree trunk.

4 Let lines define shapes.

5 Stippling and scattered lines for transitions.

6 Lines and reflection show water.

3 FINISH WITH INK

Use your #102 nib to sketch along the pencil lines. Change the pencil lines if you feel it will be more interesting. Fill in the area behind the tree where it will be darker to pop out the trunk of the main tree. Use less detail in the middle trunk to give more interest to the group. Use fewer lines when indicating grass in the foreground and trees in the distance.

3 ADDING COLOR

Adding color to your pen-and-ink sketch can add a sparkle to your drawing that cannot be achieved using black and white alone. Incorporating watercolor into an ink drawing can be done in two ways:

- Produce the ink drawing first and fill in between the ink lines with light watercolor glazes (painting one layer over another)

- Lay down watercolor washes first and when the watercolor is completely dry, sketch with ink over the top.

There are benefits to both ways. When you're first learning, it is easier to fill in an ink drawing. Just remember always that ink wants to be the dominant media, so be careful not to dilute the ink lines. Make sure your inks are completely dry before adding color. Or, if you ink on top of watercolor, be sure the paint is completely dry before adding ink.

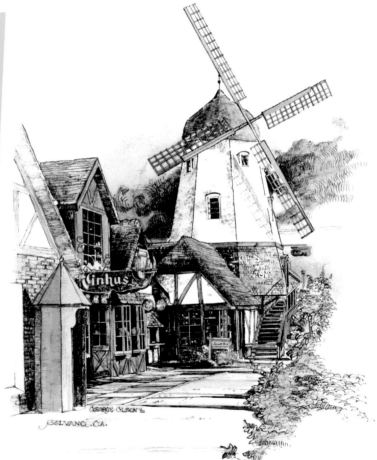

WINDMILL AT THE DANISH TOWN OF SOLVANG, CALIFORNIA
WATERCOLOR ON SMOOTH ILLUSTRATION BOARD
20"× 30" (51CM × 76CM)

Hue and Value

Understanding the attributes of color will make choosing colors for your drawings and paintings a lot easier. Here, we'll deal with two of color's attributes:

- *Hue*, the name of a color

- And *Value*, the brightness or darkness of a color. It is what differentiates dark blue from light blue.

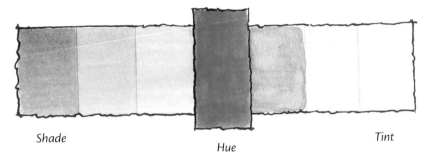

Shade Hue Tint

Value

Value is the lightness or darkness of a color. With watercolors and inks, you can add water to get lighter values called *tints*. And you can add black to get darker values or *shades*.

Graded Value Wash

With watercolors, you'll often want to make graded value changes. That is, you alter the value changes softly.

What Is a Good Color Scheme?

A good color scheme:

- Pleases the artist (that is, you like it)

- Is appropriate for its purpose (Is it masculine or feminine, rough or smooth, cool or warm?)

- Possesses unity (repeating the color in different parts of the picture or mixing complimentaries to tie colors together.

- Has variety (not boring)

The Color Wheel

To best use the attributes of color in your work, you'll need to become familiar with the color wheel. The color wheel consists of primary, secondary and tertiary colors. *Primary colors* are red, yellow and blue. When you mix primary colors together the results are *secondary colors*: violet (red and blue), green (yellow and blue), and orange (red and yellow). When you mix a primary color with one of its secondary colors, you get a *tertiary color*. For instance, blue and green will give you the tertiary color blue-green.

Using the color wheel will help you to develop a color scheme rather quickly.

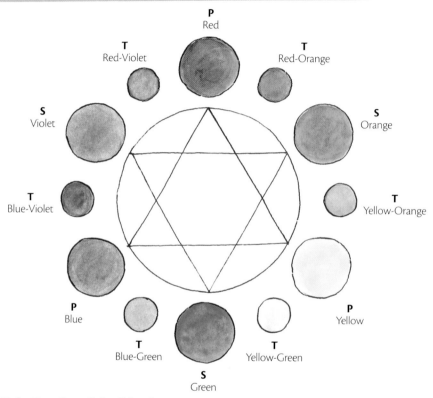

P
Red

T
Red-Violet

T
Red-Orange

S
Violet

S
Orange

T
Blue-Violet

T
Yellow-Orange

P
Blue

P
Yellow

T
Blue-Green

T
Yellow-Green

S
Green

Make Your Own Color Wheel

Creating a color wheel like this one will help familiarize you with the way colors work together. Begin with one triangle and the three primary colors. Add another triangle to add the secondary colors, then use the spaces in between to place the tertiary colors.

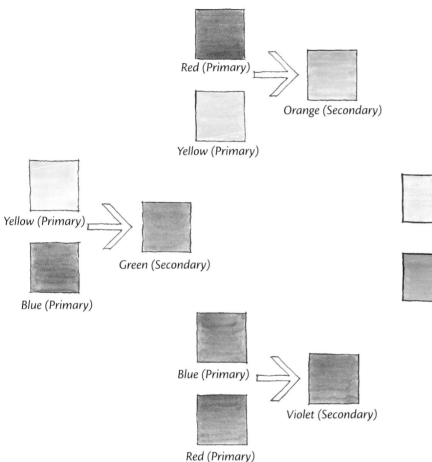

Red (Primary)

Orange (Secondary)

Yellow (Primary)

Yellow (Primary)

Green (Secondary)

Blue (Primary)

Blue (Primary)

Violet (Secondary)

Red (Primary)

Tertiary Colors

Mix any primary color with one of its secondary colors to get a tertiary. Here blue and green give you blue-green. See the color wheel on page 70 for more examples.

Secondary Colors

Create a secondary color by combining two primary colors. Blue and yellow produce green, yellow and red produce orange, and blue and red produce violet.

Color Trick

Stare at a color for a minute or two. Close your eyes. The afterimage you see with your eyes closed will be the complementary color.

Complementary Colors

Two colors opposite each other on the color wheel instantly attract attention when placed next to each other.

Split Complementary

A split complement consists of one color, which becomes an accent or contrasting color, and the two colors on either side of that color's complement. This gives you a nice range. So here you have red in addition to blue-green and yellow-green.

Monochromatic

For a nice, simple color scheme try using only one color, which you then lighten or darken.

Analogous

Analogous colors are colors next to each other on the color wheel. They're always a safe bet for harmonious compositions.

Triad

A triad consists of three colors evenly spaced on the color wheel. When you use triads, make sure that only one of the colors is dominant in your painting.

Colored Inks

Colored inks, for the most part, are very bright but you can easily tone them down by diluting them with water (preferably distilled) or mixing them. They can be mixed the same as watercolors and are very transparent. When dry, they are permanent and cannot be changed or removed like watercolor.

They come in a large variety of hues. But, like watercolors, it is best to not use too many of them. The primary colors, red, yellow and blue, can be mixed to produce any of the other hues but, for simplicity, you may want to have several of the basic colors you always use on hand.

Other hues can be created also by using crosshatching. For instance, crosshatching yellow and blue will give the effect of green.

WHERE TO BEGIN

First try working with one color, such as brown or sepia on a simple drawing. Some artists like to use several pens, one for each color. I like to use two nibs: one for darks and the other for lights.

When you finish inking with one color, clean the nib with a paper towel before dipping it into another color. You don't want to mix the pigments together in their bottles.

A WORD ON DRAWING SURFACES

Practice on tinted surfaces such as a cream, light gray or light brown. The color of the drawing surface will help tone down the bright hues. Adding white (opaque) ink to the other colors will increase the opaqueness of the color, reducing its transparency.

Pure Ink

Diluted Ink

Colored Ink on a Pure White Surface Can Be Too Bright

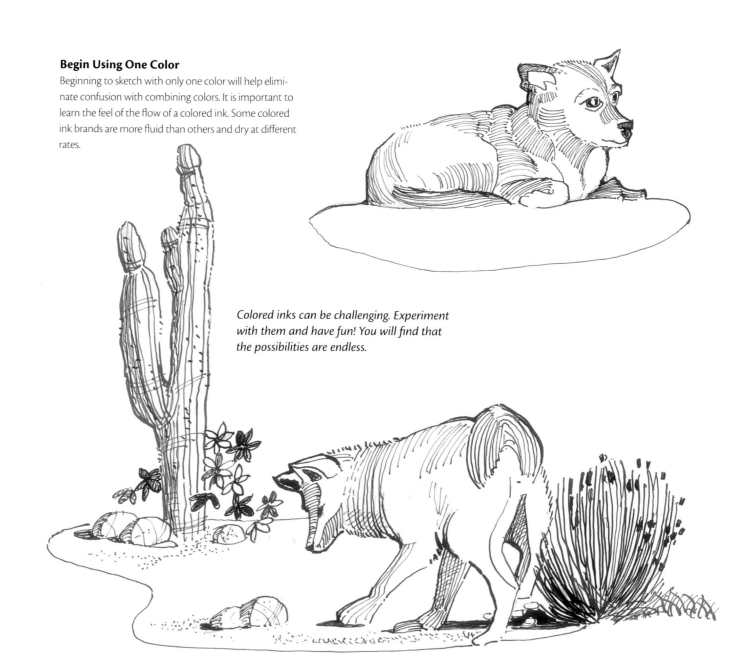

Begin Using One Color

Beginning to sketch with only one color will help elimi-
nate confusion with combining colors. It is important to
learn the feel of the flow of a colored ink. Some colored
ink brands are more fluid than others and dry at different
rates.

*Colored inks can be challenging. Experiment
with them and have fun! You will find that
the possibilities are endless.*

Using Colored Inks

WHAT YOU NEED

- Paper for inking
- Colored inks: red, blue and yellow
- #102 crow quill nib and holder

The techniques you use for colored inks don't differ much from the techniques you use for black ink. Here we'll explore almost the very same strokes that would be used to sketch in black. However, now that color is introduced, the lessons on color come into play; which adds a dimension black ink does not have.

Adjusting Value Using One Color

Practice making value scales using just one of your colored inks. The process is the same as making a value scale using black ink.

Adjust Values Using Different Colors

Begin with blue ink. After it dries, go over the squiggles with red to create the violet. Keep layering the squiggles, alternating between blue and red, to get the values from dark to light.

Red Orange Yellow Yellow Green Blue

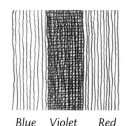

Blue Violet Red

Crosshatching to Change Hues

You learned earlier how to make secondary colors by combining the primary colors. With inks you can do this by applying lines over top of each other. Follow this chart as you crosshatch to create the secondary colors orange, green and violet.

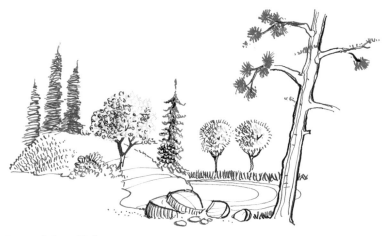

Layer Colored Inks

Layering your squiggles, lines and stipple marks with colored inks gives you a lot of color options.

Adding Volume Using Colored Inks

Repeat the exercises you did on pages 46-47, only this time use your colored inks. You use the same techniques.

Practice Textures

These are just some of the fun textures you can make with color. Turn to the following pages for a complete demonstration.

Drawing With Colored Inks

WHAT YOU NEED

- Smooth paper for inking
- Colored inks: Blue, green and brown (or sepia)
- India ink
- #102 crow quill nib and holder
- 2B Pencil
- Kneaded eraser
- Protective sheet
- Tracing paper

Colored ink technique follows the same procedure you have been practicing with black ink. Plan on where you want use certain colors and introduce values based on the subject matter. Remember that cool colors, such as blue, recede while warm colors, such as red and yellow, come forward.

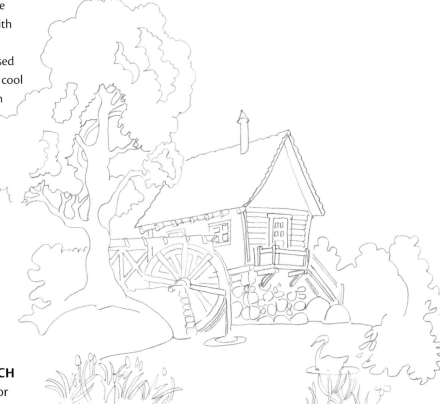

1 CREATE THE OUTLINE SKETCH
Copy or trace the main shapes for the outline sketch.

2 CREATE DETAILED PENCIL DRAWING

Do the detailed pencil sketch in the same way as if you were using black ink. Apply the pencil strokes that will act as a guide for the colored ink strokes. Apply the dark values that will help the the building, water wheel and sluice box pop out.

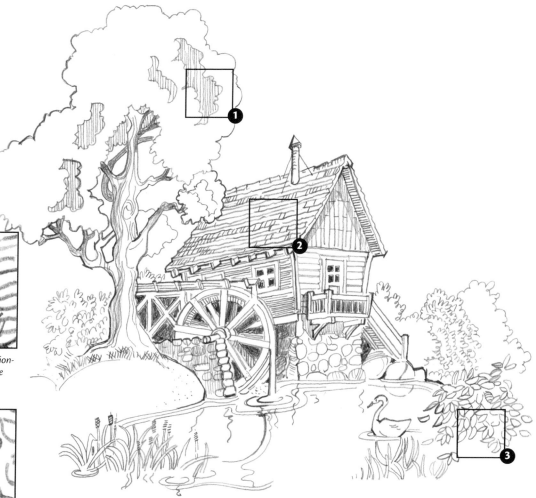

1 *Use parallel lines for shadows in the trees.*

2 *Wavy lines with occasional diagonal lines create the roof tiles.*

3 *Use simple shapes for bushes.*

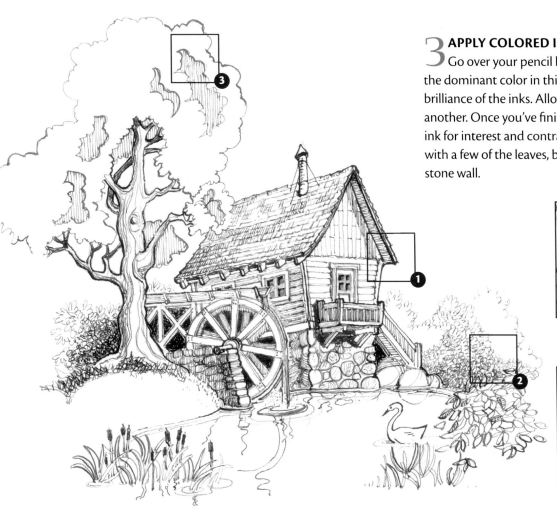

3 APPLY COLORED INK AND THEN BLACK TO FINISH

Go over your pencil lines with the colored inks. Brown becomes the dominant color in this composition, helping to tone down the brilliance of the inks. Allow each layer of ink to dry before applying another. Once you've finished adding color, go back in with some India ink for interest and contrast. Outline the swan with the black, along with a few of the leaves, bushes and the shadow sides of the tree and stone wall.

1 Dark brown lines give dimension to roof.

2 Black squiggles over the blue add interest.

3 Green parallel lines against the white tree interior give the tree depth.

Watercolor Supplies

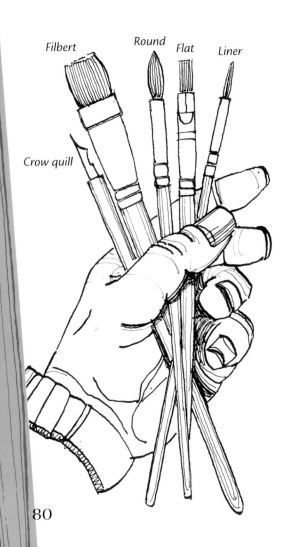

Filbert Round Flat Liner

Crow quill

The basic tools you need to add watercolor to your pen-and-ink drawings can be found in most stores that carry art and craft supplies or on the Internet.

BRUSHES

Choosing good brushes is like choosing good friends. They will last a long time and give you much happiness as long as you treat them well. Select a brush that holds an ample amount of water and springs back into shape after each stroke. You are looking for strength, spring and color-holding capacity.

Each type of brush has its own special use.

- **Round** brushes are rounded at the base and end in a point. They can be used to create broad washes or fine lines all in a single stroke. It's good to have a variety of sizes of this brush. The sizes vary from one manufacturer to another.

- **Flat** brush sizes refer to the width of the hairs from side to side. This brush produces strokes from flat and full to looser and less controlled. You can even create dots and dashes.

- **Filbert** brushes are similar to flats, except they have rounded corners and are useful to eliminate hard edges.

- **Liner** brushes are used to paint long continuous lines and to add in highlights.

PAINTS

Although tube watercolors are the most commonly used, you can also find watercolors in cakes, pans, liquids and, most recently, in pencils. You will be using pan watercolors for the exercises to follow. Pan colors are easy

Pan watercolors

to work with, offer bright, clean colors and are convenient when working outdoors. There are many manufacturers, but the best results come from professional-artist grades. I use a Prang set, which is widely available. The colors are semimoist and really are a pleasure to work with.

SURFACES FOR WATERCOLOR

There are many surfaces suitable for watercolor painting, such as vellum, parchment, clay mineral

panels, sumi rice paper and even thin fabrics such as silk. To begin with, though, you will need to purchase:

- Several sheets of 9" x 12" (23cm x 30cm) smooth, Crescent watercolor board

- A tablet of size 9" x 12" (23cm x 30cm) smooth white acid-free 140-lb. (300gsm) bristol board. (Arches makes an excellent acid-free very smooth surface hot-pressed white watercolor paper.)

Watercolor surfaces

- An 8" x 10" (20cm x 25cm) sketchbook, smooth surface 140-lb. (300gsm) white foamcore board. This is excellent for quick field sketches as pen nibs flow very smoothly over it.

Sketchbook

Why use a special watercolor paper rather than ordinary paper? Watercolor paper is specially made to be resilient and to absorb water evenly and slowly. Because watercolors are transparent, absorbency takes on enhanced importance. Thicker and heavier paper controls water absorption leaving behind beautiful, vibrant colors. Professional watercolor papers are acid-free, stronger, more enduring and, with proper treatment, allow paintings to last for hundreds of years.

PALETTE

You will need a white plate or palette to thin and mix your watercolor on. It will be necessary for you to clean off your plate often with warm water and mild soap. If

White plate

you need a larger amount of a specific color, you might try plastic egg cartons or even ice cube trays. Choosing a palette is a matter of personal preference. To begin I suggest a white plastic plate to keep things simple and inexpensive. A number of convenient, small plastic palettes are available at any craft or art supply store, too.

OTHER HELPFUL ITEMS

- **Two jars or large glasses** for water (clean and dirty). Use clean water for mixing colors and the other water becomes dirty as you clean your brushes.

Clean water *Dirty water*

- **Hair dryer** to speed up the paint-drying process.

Hair dryer

- **Watercolor paper artist tape** is specially designed to stick securely to watercolor paper, yet releasing cleanly. You will be using it for painting hard lines, or tear it to mask irregular shapes. I use 3M's Scotch brand.

Artist's tape

It removes easily without leaving residue, or bleed-through, and without damaging paper surfaces.

- **Art knife and razor blades** to remove unwanted color or any mistakes.

Art knife and razor blade

- **Tackle box** to conveniently store paints and other supplies. They come in a variety of sizes so find the one that is best suited for your needs.

Tackle box

- **Paper towels** for quick and easy clean-ups. You will also find them a must to lift excess paint from your work.

Sponges

Paper towels

- **Sponges** to lift paint from paper and assist with water spills. They come in a variety of sizes and kinds.

- **Liquid masking fluid and rubber cement** to apply to areas of your work that you want to remain white.

Liquid masking fluid

- **Large cup, glass or jar** to hold your brushes, pens, art knives and pencils. Choose a container with a wide mouth and a heavy bottom. The weighty bottom will give your container stability.

Large container

Be Kind to Your Brushes

After use, rinse your brushes thoroughly using water with soap or mild shampoo. Lay them flat to dry. Then run the bristles through your fingers to reshape them before storing. Store in your container with brush end up. This procedure will limit damage to the bristles.

Watercolor Characteristics

Watercolor has a freshness that other mediums do not have and it is easy to use. The great advantage of painting with watercolors is that their water base allows them to dry very quickly. This makes painting at different locations more convenient. They are easy to clean up as they are water-soluble. Watercolors are made of pigment mixed with the binder gum arabic. Gum arabic, a nontoxic, natural product, is water-soluble, slightly acidic, and a relatively weak binder. Painters can thin watercolors because of the weakness of the binder. If watercolors are applied too thickly, the dried color will crack.

THE MYSTERY OF WATERCOLOR

Watercolor has a tendency to keep the artist in suspense. The colors are lighter when they are dry than when wet, so you need to take that into consideration. Watercolor is also often unpredictable, unforgiving and loves to get out of control. These characteristics make working with watercolor exciting, challenging and, most of all, fun! As you practice and experiment, you will find the techniques that will enable you to be in control of this fascinating medium.

HOW TO BEGIN

Always begin painting from light to dark. Adding light colors later can be difficult. The transparency of watercolors causes the darker hues to domi- nate over the lighter ones. Watercolor painters traditionally use washes of color. A *wash* is a thin layer of paint spread over a large area of the painting. Washes are applied one on top of the other (allowing one to dry before applying the next) in order to create depth of color and to add detail.

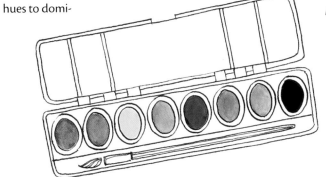

My Palette
My palette is a simple array of eight colors: red, orange, yellow, green, blue, purple, brown and black. I use inexpensive pan watercolors purchased at a local craft store.

Practice Basic Techniques

WHAT YOU NEED

- 9" x 12" (23cm x 30cm) smooth bristol board
- Pan watercolor set
- ½-inch (12mm) flat

Adding watercolor to your ink sketches requires learning some watercolor techniques. For the exercises to come you'll use four ways to express watercolor.

- **Wet-on-Wet**, which is just what it sounds like, wet paint applied to wet paper. It's good for soft edges.

- **Wet-on-Dry** is when you use a wet brush on dry paper.

- **Washes** created as you apply a watery film with color either flat or graded.

- **Glazes** are very thin layers of paint applied over dried layers. The purpose is to build color values and intensity. You will use this with ink sketches for great control without the risk of weakening the ink lines. Use a hair dryer to speed up drying time.

Combinations of these result in unlimited ways to express yourself. In this book we are more concerned with controlled washes and glazes applied within ink lines. To practice more free, aggressive watercolor styles and techniques, investigate *No Experience Required: Watercolor* by Carol Cooper (North Light Books, 2004).

To experience what watercolor can do, start by drawing squares on your paper to practice your washes and glazes in.

FLAT WASH

1 APPLY THE FIRST STROKE
Tilt your working surface at a slight angle. Fully load your flat brush with color. Apply a wet, juicy brushstroke in a horizontal motion across the top .

2 RELOAD AND CONTINUE
Quickly reload your brush with the same color and repeat the horizontal stroke, grabbing the bead of paint that formed at the bottom edge of your first stroke.

3 FINISH
Repeat the process as you work your way down the paper. Avoid going back and forth over the same stroke. Lay the wash flat and allow it to dry. Your wash should be evenly colored.

GRADED WASH

1 APPLY THE FIRST STROKE
Tilt your working surface. Wet and load your brush with color, the first brushstroke will be the darkest application. Apply a horizontal stroke across the top of your paper using your flat brush.

2 CONTINUE WITH A DILUTED STROKE
Dip your brush into water to dilute the paint already on it. Grab the bead of paint that formed on the bottom edge of your first stroke and apply the second stroke.

3 FINISH
Continue this process, dipping your brush into the water between horizontal strokes. The bottom of your wash should have little or no color.

WET-ON-WET

WET-ON-DRY

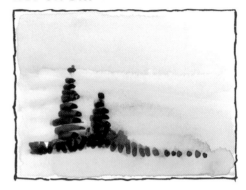

1 APPLY THE FIRST WASH
Wet your paper. Fill your wet flat with lots of yellow and apply as a wash.

2 ADD COLOR TO WET COLOR
While your paper is still wet, fill a wet brush with blue and drop it into the still wet yellow wash.

1 PAINT ON DRY PAPER
To paint wet-on-dry, you wait until the paper is completely dry before painting. This will give you sharper edges.

GLAZING

1 BEGIN THE GLAZE
With a mixture of not too much water or color, apply an even color over the surface. Let dry.

2 ADD SECOND LAYER
When the first layer is dry, repeat the same step. The color can be laid in even strokes or scrubbed lightly to keep the color even. Let dry.

3 CONTINUE LAYERING
Again, when the paint is dry (not before or it will be hard to keep the even color), apply very little water and pigment. This can be done as many times as needed to get the value you want.

86

Glazing to Create Form

WHAT YOU NEED

- 9" x 12" (23cm x 30cm) smooth bristol board
- Pan watercolor set
- No. 6 round
- 2B pencil
- Kneaded eraser

Glazing is a very safe way to keep from making mistakes when applying and building color into ink drawings, because you add only small amounts of paint at a time. Practice glazing on simple objects at first. I generally use a no. 6 round because it can lay flat strokes or can be scrubbed to fill in tight angular or irregular small shapes.

Create Form in Three Steps

1 Make a pencil drawing.
2 Apply a light wash.
3 Glaze over the wash with more color.

1 Apply wash very lightly with a small amount of water.

2 No shadow implied.

3 Keep glazing over the dried wash with the same color.

4 Hard edge.

5 Soft edge. Apply a little water or a diluted brushful of paint into a darker section. The water causes the edge to soften (see wet-on-wet, page 86) and becomes a blend that eliminates a hard edge.

6 Same color glaze gives the sphere dimension.

How to Fix Watercolor Mistakes

You can't totally remove dried paint, but you can lighten it. Scrape with a razor blade or craft knife or re-wet the area and blot with a tissue. To remove wet paint, just blot the wet area with a tissue.

LIGHT WASH

GLAZING

PENCIL

Pairing Ink With Watercolor

Pairing watercolor with ink adds a lot of interest. Some ink sketches in black, or sepia, and white look better without color; however, color gives another dimension.

Sometimes it is better to use a less detailed outline sketch to add color to. You'll use color for the shading and values that normally would be expressed with ink lines. As you become more skilled with the two mediums, you will develop a sense of when to, and when not to, pair them.

In this book we will be mostly using soft glazes, and a technique similar to "paint-by-number" painting to add color within the ink sketch.

I used crosshatching to define the form of the tree and the background in this painting. However, I left more space for color to do the work in areas such as the mushroom cap. As you prepare to add color to your ink drawings, think about where you will add color in advance.

Summer love by George Olen 02

SUMMER LOVE
INDIA INK WITH WATERCOLOR ON PAPER
8½" × 11" (22CM × 28CM)

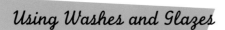

Using Washes and Glazes

Avoid painting over the ink lines when filling in with controlled light washes and glazes. If you paint over your existing lines, you're likely to lighten them.

88

Use More Detail for Ink-Only Pieces

When color is not used in an ink-only drawing, more detail is needed. Detail makes up for the lack of color to express the different parts of the drawing.

Use Less Detail for Watercolor Pieces

India ink is water-soluble just like watercolors. And while you *can* add watercolors over top of ink lines without smearing them, it is easier to preserve the ink lines if there are fewer of them.

Finished Pen and Ink With Watercolor

Combining the two mediums allows you to use ink for harder edges, such as the rim of the cup, and to use watercolor to define softer edges, such as the indentation in the middle of the cup.

Scrub Lightly!

When scrubbing with a brush, do so lightly to avoid damaging your bristles.

Paint Simple Subjects

As with any new skill, it's best to start with easier subjects when learning watercolor. Use the wash techniques you learned on page 85.

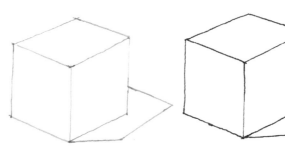

WHAT YOU NEED

- Smooth bristol board
- Pan watercolor set
- India ink
- #102 crow quill nib and holder
- No. 6 round
- 2B pencil
- Kneaded eraser
- Protective sheet

1 BEGIN WITH AN OUTLINE PENCIL SKETCH
Draw an outline sketch of a simple cube.

2 CREATE THE INK SKETCH WITHOUT DETAILS
Trace over the cube with ink.

3 APPLY THE FIRST WASHES
Apply a light wash and allow it to dry. Continue applying washes to get different values for the different sides of the cube. Remember, the darkest value should be the cube's cast shadow, so add a little black or brown to your color to achieve that.

4 FINISH THE OBJECT
Allow the paint to dry. Go back in with your inks to add additional shading in the shadow areas. Leave the lightest areas without additional ink.

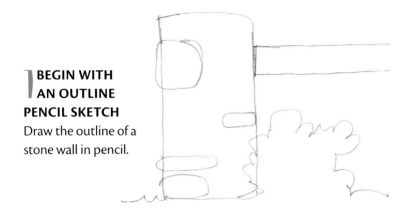

1 BEGIN WITH AN OUTLINE PENCIL SKETCH

Draw the outline of a stone wall in pencil.

2 CREATE THE INK SKETCH WITHOUT DETAILS

Without a lot of detail, trace over the pencil with ink.

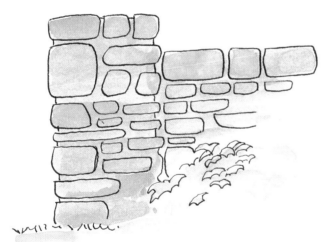

3 APPLY THE INITIAL WASHES

Allow the ink to dry completely. Using just the main colors, here brown and green, apply light washes over the ink outline sketch.

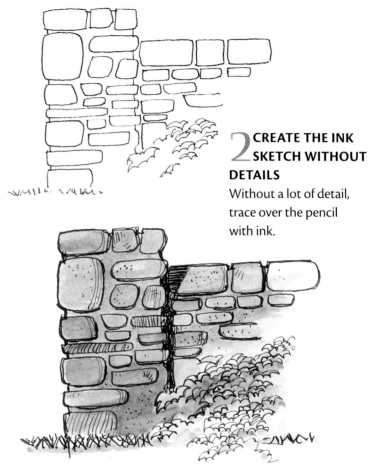

4 FINISH THE WALL

Allow the initial washes to dry. Using green, orange, blue and brown mixtures, vary the colors on the individual stones. Add additional ink lines for interest after the watercolor is dry.

Paint a Flower

- Smooth bristol board

- Pan watercolor set

- India ink

- #102 crow quill nib and holder

- No. 6 round

- 2B pencil

- Kneaded eraser

- Protective sheet

Flowers are available most everywhere and really wonderful to paint. The yellow daisies from this bunch will be easy to sketch and paint due to the simplicity of their shapes. Use the pen-and-ink and watercolor techniques you've practiced so far. Remember, you won't need much ink detail.

Reference Photo
This photo was taken with a disposable camera.

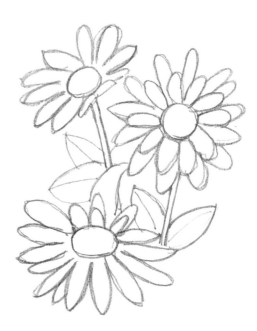

BEGIN WITH AN OUTLINE DRAWING
Since the flower is a fairly simple composition, draw the outline drawing freehand. Break the flower down into simple shapes.

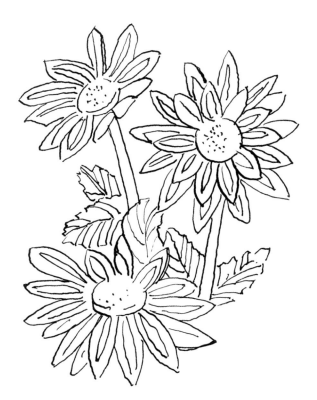

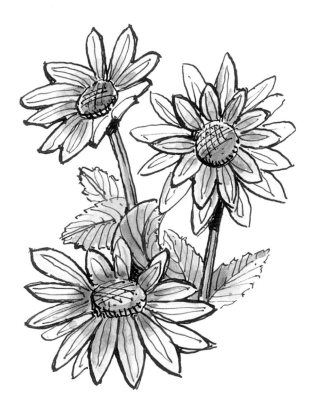

2 COMPLETE THE OUTLINED INK DRAWING

Go over your outline pencil marks with your #102 nib. Add interior lines to each petal. These will guide you as you add color. A few stipple marks add texture. Erase any extra pencil marks after the ink dries.

3 ADD WATERCOLOR TO FINISH

Once your ink drawing is completely dry, you're ready to add some color. Use yellow, orange and green (tone the green down with some water). A little blue added here and there will give the leaves and petals some colorful depth and shading.

Allow the paint to dry. Then go back in with your crow quill. Add just a few crosshatched marks and parallel lines inside the flower.

Paint a Landscape

WHAT YOU NEED

- Smooth bristol board
- Pan watercolor set
- India ink
- #102 crow quill nib and holder
- No. 6 round
- 2B pencil
- Kneaded eraser
- Protective sheet

Practice looking at landscapes both as a whole and as small vignettes of the whole. In this demonstration you'll paint a small vignette of a larger scene. You'll use little ink detail, allowing for more expression with color. Though, you might also try this with a more detailed ink sketch and using just a small touch of color.

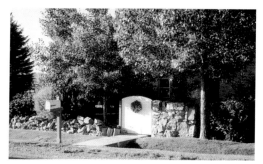
Reference Photo

1 BEGIN WITH AN OUTLINE DRAWING

Using the photograph, prepare a simple outline drawing. Remember, you're only looking for basic shapes at this point. Draw freehand and don't be too concerned with details.

2 PREPARE THE INK DRAWING

Ink over the pencil sketch to produce a simple ink outline drawing. Don't add any details yet. In this exercise, you're going to add additional line detail *after* you add paint. After the ink dries, erase any stray pencil marks.

94

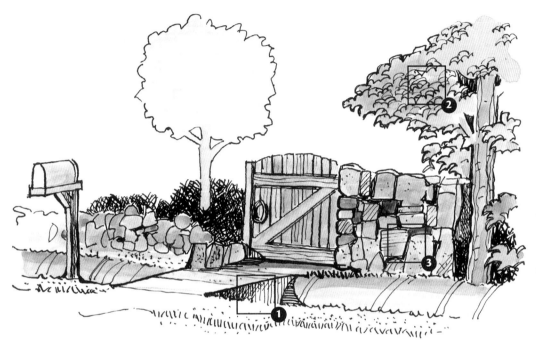

3 ADD WATERCOLOR TO FINISH

Don't worry about exact colors. Play with the paint. Practice making different values by mixing more or less water with the blue, brown, green and yellow pigments in your watercolor set.

When you're finished, allow the paint to dry. Then go back in and add additional ink lines and stippling to create texture details using your crow quill.

1 Parallel lines and crosshatching give depth to the walkway.

2 Little waves over the solid tree hue indicate leaves.

3 Randomly scattered lines and dots over the stones give them texture.

Paint a Bird

WHAT YOU NEED

- 8" x 10" (20cm x 25cm) smooth bristol board
- Pan watercolor set
- India ink
- #102 crow quill nib and holder
- No. 6 round
- 2B pencil
- Kneaded eraser
- Protective sheet

Lucky for us, birds are everywhere. They don't hold still well though, so you'll have to take lots of photos to paint from. For this demonstration, I used a ceramic sculpture. Copy the outline, then follow along to add detail and color.

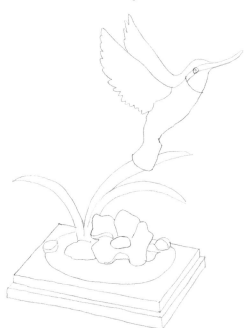

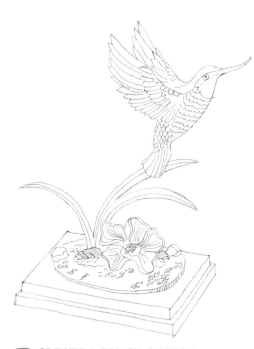

1 OUTLINE THE PENCIL SKETCH
On a piece of bristol board, sketch the hummingbird and start a pencil outline as before to establish your composition.

2 CREATE A PENCIL SKETCH
Continue with pencil sketch lines hinting at the lines you plan to use when inking.

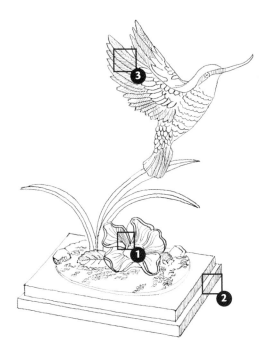

3 CREATE THE INK SKETCH
Follow the pencil lines as a guide. Change the pencil lines if you feel it will make the drawing more interesting.

1 *Softly curved lines for the inside of the flower.*

2 *Parallel lines for the shading on the dark side of the pedestal.*

3 *Series of diagonal lines for the feathers.*

4 ADD WATERCOLOR TO FINISH
Use light glazes to add the different values. You'll want to use a lot of water with the red to get the light interior of the flower.

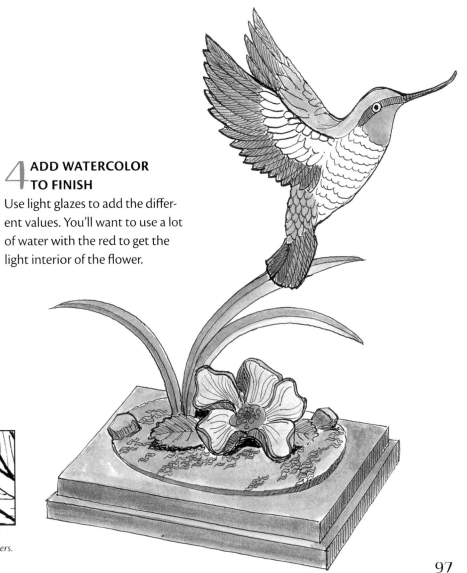

Paint Animals With a Background

WHAT YOU NEED

- Smooth bristol board
- Pan watercolor set
- India ink
- #102 crow quill nib and holder
- No. 6 round
- 2B pencil
- Kneaded eraser
- Protective sheet
- Straightedge (optional)

Look for the basic shapes when drawing animals, just like you would when drawing anything else. Keep in mind that most animals anatomically share the same features (tails, four legs, etc.). This may seem obvious, but remembering this helps when you are sketching. Just draw what you see.

1 PREPARE THE OUTLINE SKETCH

Here I have used some vertical and horizontal lines (you may want to use a straightedge to keep your lines square and parallel) to tie the sketch together. Copy this outline pencil drawing onto smooth bristol board.

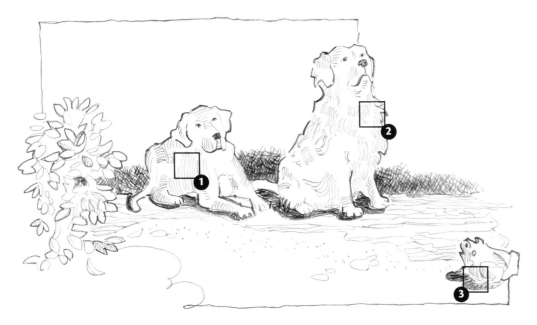

2 MAKE A DETAILED PENCIL DRAWING

Add details to dogs' fur and body shape. As you form your lines, picture in your mind how the drawing will look when finished in ink and color.

1 *Parallel lines for the smooth coat of the Labrador retriever.*

2 *Wavy strokes for the golden retriever.*

3 *Indicate the dark cast shadows.*

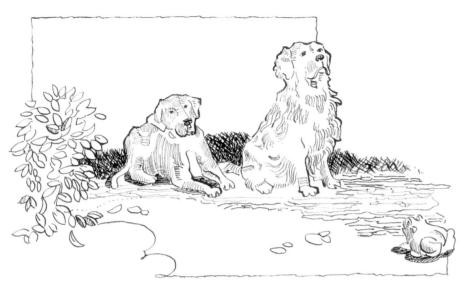

3 COMPLETE THE INK DRAWING
Go over your pencil lines with ink. Here, I left out the stippling I'd penciled in earlier because I decided it would look better if I added it after painting. Feel free to make these sorts of decisions as you work.

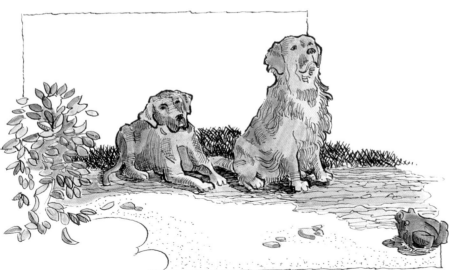

4 ADD WATERCOLOR TO FINISH
Most of the ink drawing (except for the stippling) should be finished at this point. Allow the ink to dry completely. Lay down glazes using blue, yellow, orange, light brown and greens with your no. 6 round. You don't want to use too much water for these glazes, as that could smear the ink. After the paint has dried, add scattered stippling with the ink to bring the picture together.

Paint a Castle Landscape

WHAT YOU NEED

- Smooth bristol board
- Pan watercolor set
- India ink
- #102 crow quill nib and holder
- No. 6 round
- 2B pencil
- Kneaded eraser
- Protective sheet
- Tracing paper

Castles conjure images of fantasy and adventure. One can imagine the knights and damsels as they lived their lives in and around the castles. Oftentimes I start sketching a rampart or tower and then just keep adding drawbridges, windows and walls to let the drawing develop.

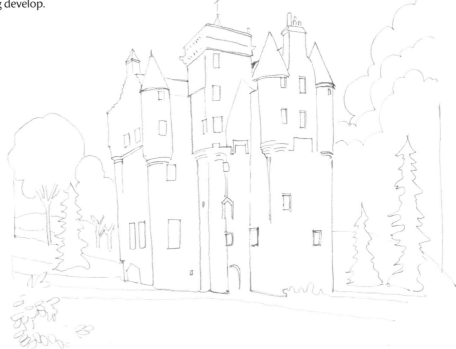

1 CREATE OUTLINE SKETCH
Use a piece of tracing paper to copy this outline sketch, or sketch it freehand if you like.

2 DETAILED PENCIL DRAWING

Notice that parts of the building cast shadows on other parts of the building. Draw guidelines for the ends of curved shadows. Your pencil sketch should become a value sketch too. You'll use it to guide you as you add ink and paint.

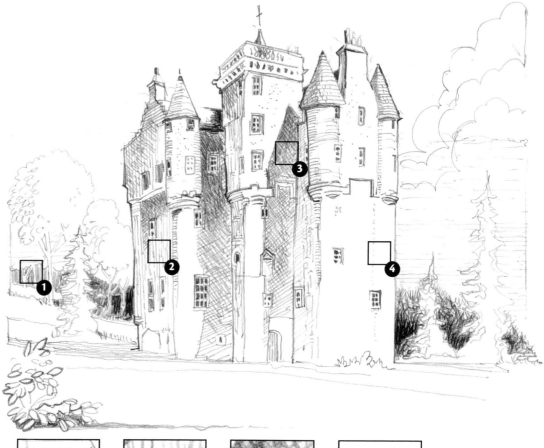

1 *Empty spaces show trees against dark background.*

2 *Light lines show midtones.*

3 *Indicate the darkest areas with heavy crosshatching.*

4 *Single line of stippling shows curve of the building.*

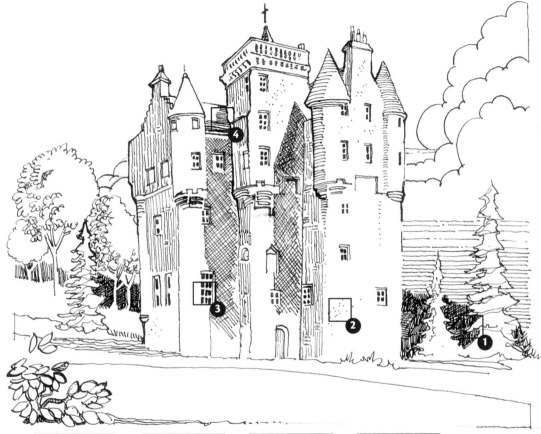

3 ADD INK

Use your pencil lines as a guide to add ink. You don't want to include everything you did in pencil though. For example, while I used crosshatching to shade in the far left side of the castle in the pencil drawing, I decided to use some broken lines in the ink drawing in order to leave more room to add watercolor.

1 *Heavy lines indicate the darkest shadows and leave room for paint on trees.*

2 *Light stippling to show texture on building.*

3 *Window panes filled in completely.*

4 *Horizontal lines complete shadow.*

103

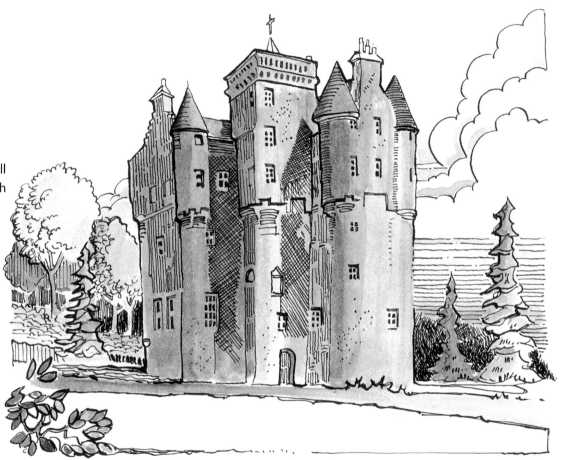

4 ADD WATERCOLOR TO FINISH

Glaze with light washes to complete the painting. Use blue on the roof, green mixed with blue for the evergreen trees, and brown mixed with black for the walls. Lighten some red to add to the far right wall and the sky. Feather in the red wall color with the brown grayish part with soft edges.

Paint a Scene—St. Nicholas

WHAT YOU NEED

- 8" x 10" (20cm x 25cm) smooth bristol board
- Pan watercolor set
- India ink
- #102 crow quill nib and holder
- No. 6 round
- No. 0 liner
- 2B pencil
- Kneaded eraser
- Protective sheet
- Tracing paper

When you are familiar with using the pen and begin to sketch people, the coloring is relatively easy. It's time to practice your new skills with ink and watercolor on a slightly more complex subject.

CREATE THE OUTLINE SKETCH

Block out St. Nick, the rocking chair and the fireplace with your 2B pencil. Remember to keep it simple: the fireplace is a series of cubes and circles, for example. Use the throw rug to tie together the gift box, St. Nicholas and the fireplace. This composition is the basis of what is to follow. Draw several studies like this so you can choose the one you like best. Once you get an outline sketch that you like, make a copy of it using the technique on page 40.

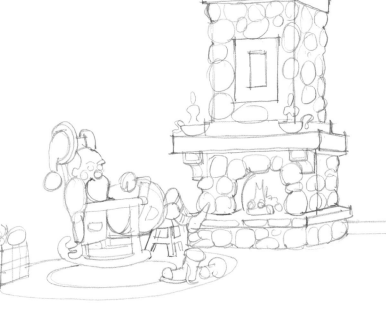

2 CREATE THE DETAILED PENCIL SKETCH

Add detail and lines that will help guide you when you ink. Use your hand protective sheet to prevent smudging the graphite.

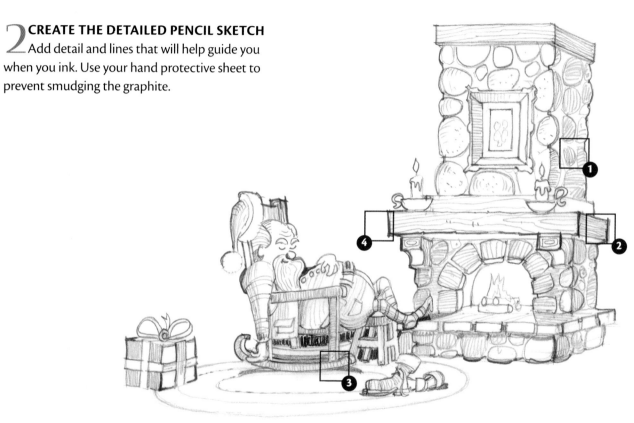

1 Add lines for shading except at the fireplace opening.

2 Draw lines that will help you decide whether or not to use them when inking.

3 Make the lines darker and closer together in shadow areas.

4 Thicken the lines at edges.

3 CREATE THE INK SKETCH

Ink over the pencil lines. Don't be afraid to change the pencil strokes if it appears a different stroke would create more interest. Clean up the pencil marks with a kneaded eraser after the ink is dry.

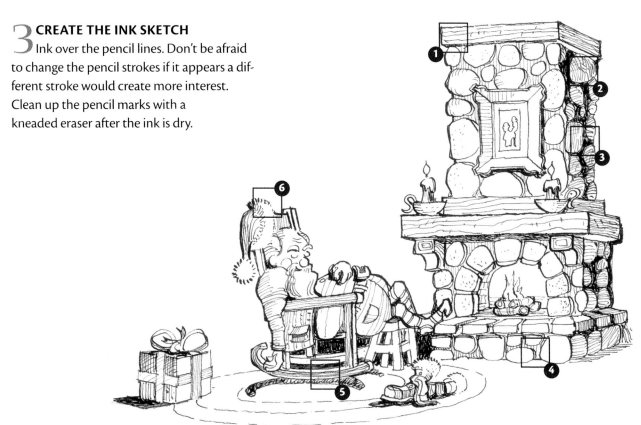

1 *Lightly ink the wood grain of the trim and the wood fireplace mantel.*

2 *Shade shadowed stones with broken lines.*

3 *Darken the mortar.*

4 *Lines in the mortar on the light side help define the stones.*

5 *Show the wood grain in the rocker.*

6 *Use short line dabs for the fur in the cap.*

107

4 APPLY THE WATERCOLOR

Be sure the ink is completely dry before adding paint. Use your white plate for mixing colors to add as you see them in this example. Remember it is not as important to match my colors as it is to apply your colors with interest. Apply the paint in thin glazes using your no. 6 round without allowing the paper to get too wet. Keep the paper on the dry side and apply just a little paint in small areas at a time to help prevent warping and to maintain the integrity of the ink. Use your no. 0 liner for very small areas such as the pink parts of St. Nick's face. Paint within the ink lines as much as possible without causing them to fade. Wait for each glaze to completely dry before adding another. A hair dryer can speed up the drying time.

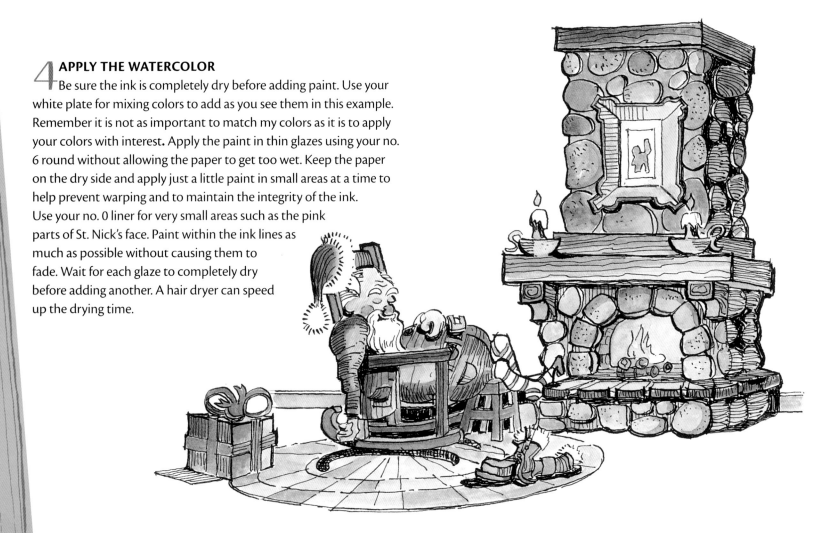

Conclusion

Congratulations! You've finished all the demonstrations. Here are a few things to remember as you continue on your artistic journey.

- Keep practicing with ink alone as well as with watercolors and colored inks.

- Use your imagination to enhance your drawings. Draw what you see, and draw what you can imagine.

- Carry your sketchbook, pencil and ballpoint pen for doodling and sketching on the go.

- Remember you are the artist! Be courageous and deviate!

WINTER TIME©
INDIA INK ON ILLUSTRATION BOARD
12" × 16" (30CM × 41CM)

Index

The Best in Art Instruction and Inspiration Comes From North Light Books!

Learn to create realistic-looking fantasy artwork with this latest book by Claudia Nice, one of the foremost pen & ink, watercolor artists and teachers. With Nice's characteristic friendly instruction you'll learn ways to create everything from unicorns to pixies and centaurs to dragons, as well as easy methods to add accessories, homes and vibrant backgrounds.

ISBN-13: 978-1-58180-618-2, ISBN-10: 1-58180-618-3 HARDCOVER, 128 PAGES, #33189

Reach greater levels of creativity, inspiration and artistic fulfillment with award-winning artist, Nita Leland's The New Creative Artist. Leland's ultimate creativity guide will help you unlock your artistic power with more than 60 fun, fabulous activities, along with loads of practical advice, exercises and even insights from other artists.

ISBN-13: 978-1-58180-756-2, ISBN-10: 1-58180-756-2, HARDCOVER, CONCEALED WIRE-O 176 PAGES, #33423

Take your pen & ink skills to a new level! Learn to create powerful sketches of plants, skies, waterscapes, animals, faces, figures and more with this classic instruction by Claudia Nice. This is the only complete guide for artists of every skill level for sketching from life in pen & ink.

ISBN-13: 978-1-58180-433-1, ISBN-10: 1-58180-433, PAPERBACK, 144 PAGES, #32601

These books and other fine North Light titles are available at your local fine art retailer or bookstore or from online suppliers. Or visit our website at www.artistsnetwork.com.